10⁰⁰

# LOUISE DAHL-WOLFE

A Photographer's Scrapbook

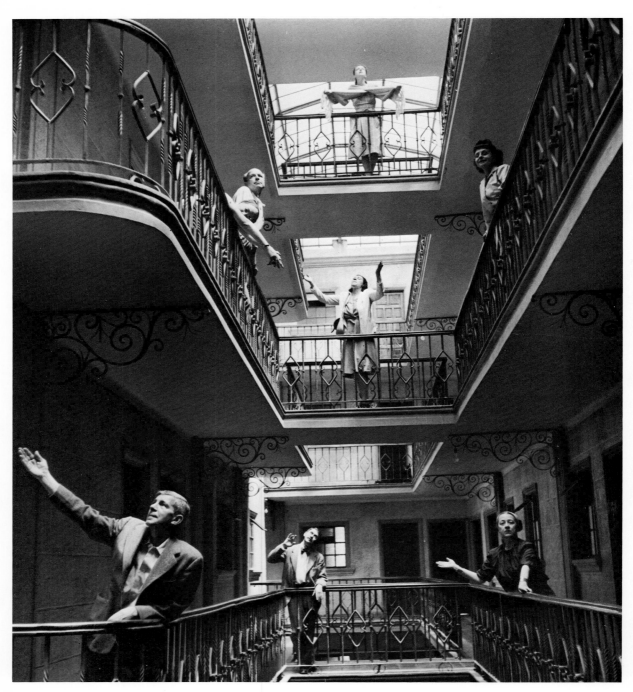

The travelers, Oaxaca, Mexico, 1947

# LOUISE DAHL-WOLFE

## A PHOTOGRAPHER'S SCRAPBOOK

PREFACE BY
FRANCES MCFADDEN

Quartet Books
London   Melbourne   New York

The Publisher wishes to gratefully acknowledge material from
*American Photographer*, volume VI, No. 6: June 1981; Profile:
Louise Dahl-Wolfe by Vicki Goldberg; and inspiration and special
help from Margaretta K. Mitchell and her book, *Recollections:* Ten
Women of Photography, published in 1979 by Viking Press.

First published in England by Quartet Books Limited 1984
A member of the Namara Group
27/29 Goodge Street, London W1P 1FD

Dahl-Wolfe, Louise
    A photographer's scrapbook.
    1. Photography, Artistic
    I. Title
    779'.092'4      TR654

ISBN 0-7043-2444-X

*For Mike, with love*

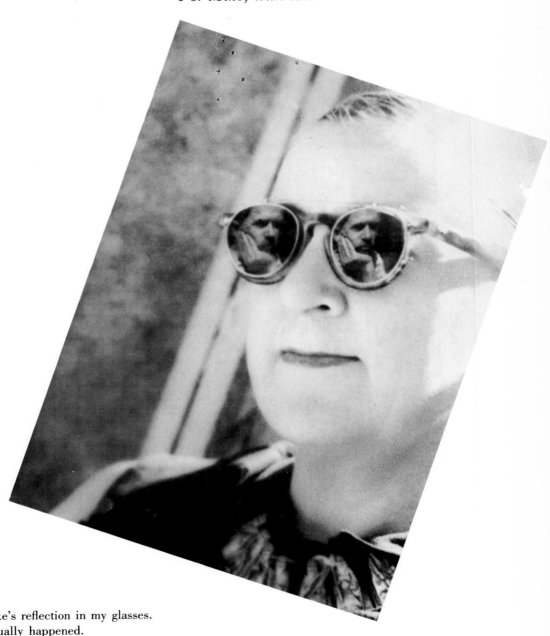

Louise, 1951. That's Mike's reflection in my glasses.
This was no trick; it actually happened.

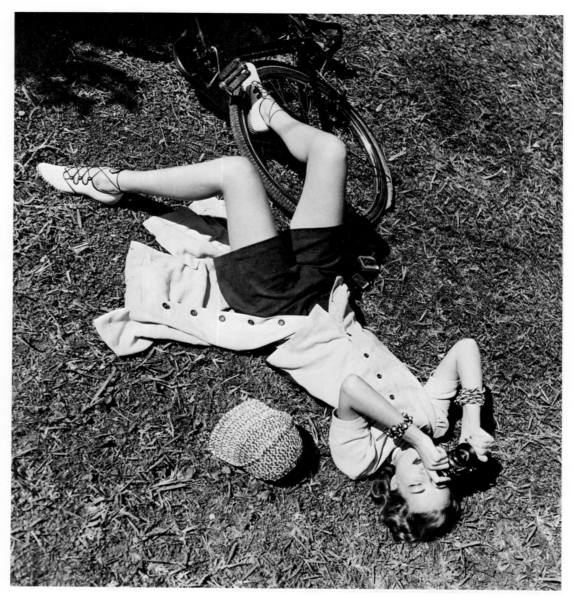

Liz Gibbons as photographer, 1938

# ACKNOWLEDGMENTS

I'll be forever grateful to my sister, Elizabeth Dahl, who suggested that I attend the San Francisco Institute of Art. It was there that I met and studied with Rudolph Schaeffer, who taught me the science and art of color. I am delighted to think of him now at ninety-five still teaching in San Francisco.

It was my excitement at seeing the work of Anne Brigman, a wonderful early San Francisco photographer, that first inspired me to try my hand at photography.

Frank Crowninshield, editor of the old *Vanity Fair*, helped build my confidence in the beginning stages of my career through his belief in and appreciation for my work.

The invitation to join *Harper's Bazaar* as a staff photographer, and to work for the star editor of the time, Carmel Snow, and her brilliant staff was a thrilling opportunity. I count it my good fortune to have had all their help and support through the years: Frances McFadden, managing editor; Alexey Brodovitch, art director; George Davis and Mary Lou Aswell, fiction editors; and Diana Vreeland, fashion editor; also Patricia Cornwell, Gwen Randolph, D. D. Dixon, and Babs Simpson, fashion editors.

I'll always remember with delight the 26 years spent in the old Sherwood Studio building, and am indebted to my young assistants who meant so much to me: Hazel Kingsbury, Hans Jorgensen, Gene Fenn, Herbert Gottesman, Margaret Hummel, Alfred Linn, Otto Fenn, and Harry Easton. And it was always a pleasure and asset to have with us Josephine Landl, who shared our studio space with her retouching and spotting business.

My gratitude to my favorite models, for all they've given me: Elizabeth Gibbons, Lisa Fonssagrives Penn, Mary Jane Russell, Evelyn Tripp Young, Toni Hollingsworth, Georgia Hamilton, Jean Patchett, Gjonji Balazs, Betty Threat, Rita Tuohy, Liz Benn, Natalie Paine, Cherry Nelms, Barbara Mullen, Georgiana Young, Suzy Parker, Dorian Leigh, Jacqueline and Luki, Betty Bond, and Bijou Barrington.

I was very lucky to work with many special and marvelous art directors: George Green, of Saks Fifth Avenue, responsible for urging me to show my work to *Harper's Bazaar;* Harry Rodman of Lord & Taylor, whose ideas possessed such great individuality; Arthur Bloomquist of J. Walter Thompson; Alberta Boutyette, whom I joined when she left Lord & Taylor to take over the art department of Bonwit Teller; Arthur Weiser of Gray Advertising, who had impeccable taste; my old friend Mike Kenzer of Simplicity Patterns; the inspiring Cipe Pinellis at *Mademoiselle* magazine; and last but not least, the *Bazaar*'s Alexey Brodovitch.

Many of the account executives were very helpful, such as the late dear, dear Lucille Platt. She handled the aristocratic ladies so brilliantly during the Ponds Cold Cream sessions for J. Walter Thompson. And my friends Carolyn Larkins and Pauline Alper were very efficient in those early years, on the Crown Rayon Account of J. M. Mathes.

Toward the end of my career, I worked for about three years for *Sports Illustrated*. Director Fred Smith and art director Benjamin Schultz suggested that I photograph, in color, male gourmet cooks and the "pièces de résistance"

they produced. I loved the job and was impressed by their artistry.

I came out of retirement in 1977, when I was talked into having a show at the Cheekwood Museum in Nashville, Tennessee. Hazel Kingsbury Strand came back from France, after her husband Paul Strand had died, bringing with her his darkroom assistant, Anne Kennedy, to help me with the printing. Annie is a great Irish beauty, and I used to wish I was back behind the camera so I could have her as my model.

Special thanks to my dear friend Sally Kirkland, who was fashion editor of *Life* magazine and an early fan of mine. She got me to dig up my past for a book, and to exhibit my photographs, and I hope I have not disappointed her!

And to my longstanding fan Charles Barton, who has been following my work since the Second World War: your loyalty has been greatly appreciated.

I want to say thanks to St. Martin's/Marek for the privilege and experience of working with such gracious and charming people as editor Joyce Engelson and assistant editor Erika Goldman, and to Phillip Bloom and Gloria Safier for getting us together.

Finally, I want to sing the praises of a remarkable person and great photographer, Edward Steichen, who in the early days of this century introduced the works of many important French painters to the Alfred Stieglitz gallery, 291, in New York City, and in the early thirties helped to advance photography by lecturing and developing future young geniuses. Steichen was the master.

JULY 1949 COVER
291

July 1949 PAGE 62
292

July 1949 PAGE 63
293

AUG 1949 COVER
294

AUG 1949 PAGE 93
295

AUG 1949 PAGE 94
296

AUG 1949 PAGE 95
297

SEPT 1949 COVER
298

SEPT 1949 PAGE 163
299

SEPT 1949 PAGE 164
300

OCT 1949 COVER
301

OCT 1949 PAGE 141
302

OCT 1949 PAGE 142
303

OCT 1949 PAGE 143
304

OCT 1949 PAGE 144
305

OCT 1949 PAGE 185
306

# PREFACE

The mid-thirties, when Louise Dahl-Wolfe's photographs first began to appear in *Harper's Bazaar*, were peak years for fashion. The skimpy dresses of the twenties had given way to more feminine, more fluid fashions. The shingle had been replaced by curls. Hats, madly becoming, sadly missing today, were making news every second. "Don't Dress" had not become protocol. The lucky survivors of the Depression—Café Society—were dining out night after night, dressed to the nines.

The fashion magazines, however, had not caught up with the tempo of the times. Edited for an old-fashioned Society (with a capital S) that had clearly had its day, they ventured as far as Newport or Palm Beach, but never west of the Hudson. Fashion editors, Paris-gowned and suede-gloved, made their rounds of the Seventh Avenue market somewhat condescendingly, unaware that American design was about to burst from those dingy lofts. Even the top photographers, stuck in old-fashioned ways, turned their studio lights on statuesque models in classic poses. Baron de Meyer still photographed under a black cotton shroud, with a hair net on his head to keep from mussing his coiffure.

When Carmel Snow took over at the *Bazaar* things began to happen. Under her new art director, Alexey Brodovitch, the old Erté covers vanished and the layouts became contemporary almost overnight. Brodovitch was Russian, once a captain in a cavalry regiment in the old Russian army. He had been teaching in Paris and at the Philadelphia Museum School of Art when Carmel sought him out and fought, bled, and died to get her superiors to accept his radical changes.

A page from my working notebook, 1949–50

Brodovitch's art department became a mecca for European artists and photographers, refugees from Hitler. Many of these photographers were crack journalists—for some it was their first try at fashion. It is hard to realize today how revolutionary their work appeared forty-odd years ago. Munkacsi's photograph of a girl racing along a beach with scarf flying created a sensation. His frontispiece of a young woman coming out of an A & P with her marketing put suburbia on the fashion map for the first time.

"Just snapshots," said the old-timers—but the truly sophisticated were entranced. In Paris, that great hostess Mrs. Reginald Fellowes was flattered to become Paris editor. She opened her town house in the heat of August for backgrounds, and covered the collections, a revolution herself, with her bare feet in sandals and her dress of white cotton piqué—*cotton*, mind you, instead of the inevitable crepe de chine.

In New York, Diana Vreeland started her career with her "Why Don't You?" feature and shortly after joined the staff. "I love royalty," she said once. "They're so clean." She set a royal standard herself—the sheen of her blue-black hair always matched the shine on her little black slippers. Her assistants, trained in her rigorous school, worked like galley slaves by day and danced their toes off at night. Sometimes these young enthusiasts ran the *Bazaar* into serious trouble. When the camel they led into the Botanical Garden devoured a rare flower that blooms only once in every one hundred years; when a yachtsman threatened to sue because Munkacsi had taken over his sloop lying at its mooring in a Long Island harbor; when a line from "Why Don't You?" got posted maliciously on the board of a fashionable men's club; when the God Almighty of the magazine, in reproof, called the new, prized artist Bébé Bérard "Faceless Freddie"—the staff trembled but also laughed immoderately, Carmel most of all.

On a spring Monday morning Carmel would blow in from the country where she spent weekends with her children, arms full of lilacs, an adorable potato chip by Suzy on her blue curls, ready to take on anything. She could trust her blarney to get her out of trouble and she knew she had a big success on her hands. When the first eastbound commercial flight of the Clipper took off she went blithely aboard, tripping down a shaky gangplank from a pier off a daisy field somewhere on Long Island. A few years later she was making the trip regularly in those slow old planes that always stopped at Gander, Newfoundland, to refuel.

Louise Dahl-Wolfe was often with her on these trips. In Paris Louise always bought just one outfit for herself. One year it was a "New Look" suit and she wore it with aplomb around New York, enjoying the sensation she created. Louise was very much a part of the *Bazaar* "family." Her own studio was a delightful place. The atmosphere, according to her sculptor husband, Meyer Wolfe, was bohemian. It was an innocent bohemianism, outside the commercial rat race—time no consideration, lots of talk, food at any hour, but always delicious; her popovers outpopped the famous ones at the Algonquin. When not faced with a deadline, she worked with her little camera on experiments with Kodachrome, experiments that were to set a new standard for color photography.

In Diana Vreeland she found the perfect

teammate. When faced by an outfit that seemed utterly hopeless to Louise, Diana would save the day by redoing a coiffure, twisting a scarf a new way, adding the gleam of an earring. It was the March 1943 cover of Betty Bacall, which Louise and Diana did together, that sent that young lady to Hollywood to become Lauren. In those peak years Hollywood was watching the *Bazaar*, not only for new faces but for new talent all along the line. The magazine was publishing the work of many new writers—some of them were soon to be famous. The first fiction editor was Beatrice Kaufman, wife of the playwright George Kaufman. Then, for many years, it was wise and witty George Davis, who brought in Carson McCullers almost straight from Georgia and who translated many of the wonderful Colette stories that had never before been published in English. Later, the fiction was selected by Mary Louise Aswell, whose taste and skill in working with young writers were unsurpassed. In *her* time the *Bazaar* published the early stories of Eudora Welty and Truman Capote and Jean Stafford, several whole novels to an issue—*Gigi* for one—and poetry by Dylan Thomas, Marianne Moore, Randall Jarrell, James Merrill, and so many more besides.

As one looks back at the peak years—the Dahl-Wolfe years—one is struck with the vitality of *Harper's Bazaar*. It had vigor combined with taste and elegance. It did not seem necessary then to put a model into contortions in order to be "with it," to introduce sex in order to prove that a dress was sexy, or to drown editorial pages with ads. What Louise Dahl-Wolfe dislikes most in photography—and indeed in everything—is fakery, sentimentality, vulgarity, faults that are necessarily more evident in our commerce-ridden age.

During a long life of very demanding work, Louise has always managed to recharge her vitality with her enthusiasms. These cover a wide range, each new one heralded with the rapture of a prospector who has found gold.

—Frances McFadden
Former Managing Editor, *Harper's Bazaar*

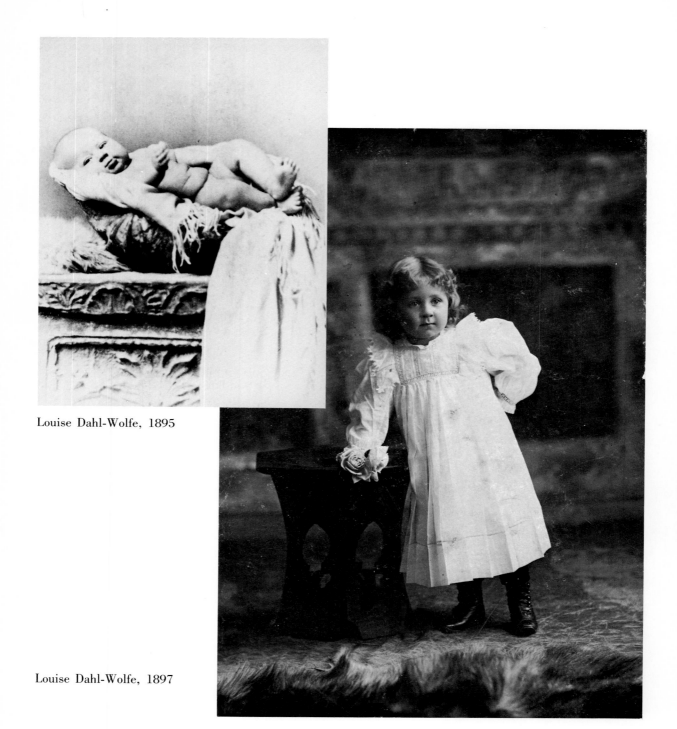

Louise Dahl-Wolfe, 1895

Louise Dahl-Wolfe, 1897

# EARLY YEARS

I was born and raised in San Francisco over eighty years ago (and named L.E.A.D. for Louise Emma Augusta Dahl, because my mother had heard it was good luck if a child's name spelled a word). My parents came from Norway. My mother's father had lost a lot of money in the timber business and bought a farm in Iowa, sight unseen. My father was an engineer and came in 1872 to work designing engines in Reading, Pennsylvania, having left Norway to avoid military service. He was a man of very definite ideas; a fan, as I am, of Thomas Jefferson. My parents met and married in San Francisco, which was a marvelous city with its large Chinese population, and a great shipbuilding port. My father soon be-

Family picnic, Muir Woods, 1897 (top row: *second and third from right*, mother Emma, father Knut)

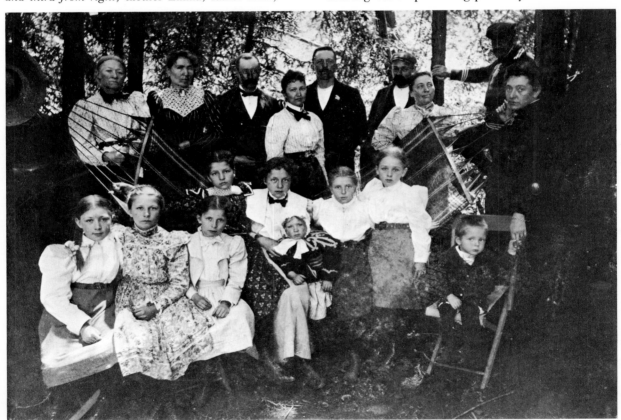

1

came the head of the marine engineering department of the Union Iron Works—later the Bethlehem Steel Company. Our family, my two sisters and I, would attend the christening of the ships on Sundays, and play was to pull out the ribbons of all the great names: the USS *Ohio*, or the USS *California*; my father's idea of entertaining a little girl was to take her to the shipyards.

One of my most vivid early memories is of the earthquake and fire of 1906, watching the endless stream of refugees fleeing to safety in the nearby hills. My job during the three days of burning was to sweep the deep ashes from the ledge on the garden fence.

# ART SCHOOL AND ANNE BRIGMAN

Persuaded by my sister and my art teacher, I became a student at the San Francisco Institute of Art on Nob Hill in 1914—it was where the Mark Hopkins Hotel is now. Art school days consisted of cast and life drawing, painting and composition, anatomy, color, and design. We drew in charcoal in life class and erased our mistakes with the rolled-up inside of sourdough bread—the recipe of the gold miners of 1849.

I had the great good luck (and I believe in luck) to study with Rudolph Schaeffer, who taught the first course in color at art school, one of the most profound experiences for me. You have to study color like the scales of the piano. It's really scientific. Later you can depend on whether you have either taste or imagination.

2

The World's Fair opened in 1915 in America even though the war was raging in Europe. For the first time in America except for the 1913 Armory Show the great treasures in painting and sculpture were collected from Europe. We saw the Impressionists and the Post-Impressionists, the old masters and the modern painters—eye openers to the young art student. Around this time I had the chance to see Diaghilev's *Ballets Russes*, and was overwhelmed by the modern sets of Picasso, Braque, and Derain, together with the costumes of Bakst, the music of Stravinsky, and the dancing of Nijinsky. To me, this was the perfect synthesis of these three arts—dance, painting, and music.

I always wanted to be a painter. I'm a frustrated painter, you know. If I couldn't be a painter, I had hoped to go to New York after art school to study interior decorating, but my father

I took this photo of the early San Francisco skyline in 1930.

Louise, student, San Francisco Institute of Art, 1915

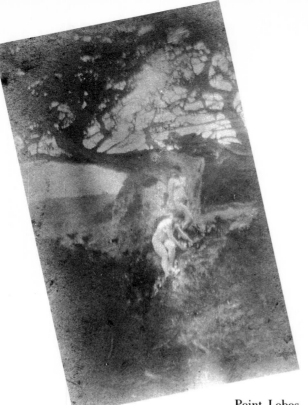

Point Lobos, 1922

died in 1919 and I stayed on, taking a job designing electric signs. It was frightfully boring and routine. And then a wonderful accident: a friend of the photographer Anne Brigman invited me to her studio. At that time photography was really not considered an art form. Brigman was part of the Stieglitz group (he devoted an issue of *Camera Work* to her photos) and they were working hard to get photography recognized. I was bowled over by my first look at Brigman's slides, her nudes taken in ice caves in the Sierra

This relates to how I got interested in photography — I was at Art school — Drawing in the life class — from the nude — when I was invited to go & see Anne Brighman — (Stieglitz showed her in his Camera Work) — I fell in love with the nudes she took in the High Sierras — in the ice caves & in Carmel + Monterey Cypress Trees — So a few Art students & I got together to do "Anne Brighmans" — I was elected to be a model — They were taken with a Brownie Box camera — !

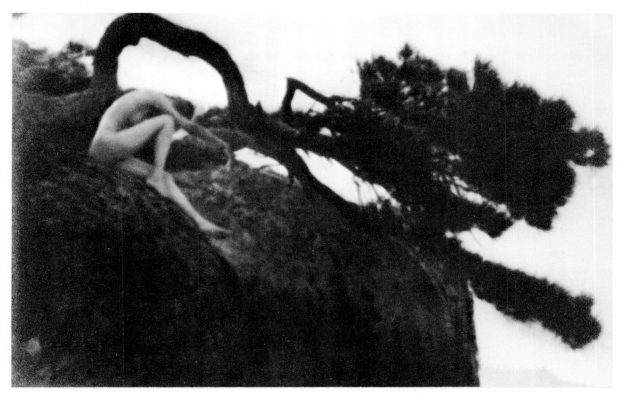

This is a photo by Anne Brigman, *The Lone Pine*, Courtesy, Metropolitan Museum of Art, The Alfred Stieglitz Collection, 1933.

Nevada Mountains and in cypress trees on Point Lobos. I was overwhelmed by the possibilities of the camera, about which I had known nothing. Everything about the visit was impressive to me; for instance, the exotic color of her studio walls, which were wooden boards stained a red-violet hue of strong intensity. One rarely saw color like that although the Bay region was beginning to use modern color because of Schaeffer's influence. He had just come back from studying in Europe, bringing color theory with him. I had to get a camera! And I was soon spending all my earnings on photography.

I visited friends in Carmel and we all decided to become photographers. We'd pose in the nude for each other, using a Brownie box fixed-focus camera, and we had the film developed at the drugstore. We were so excited by the results that we took the film to Mr. Dassonville, a well-known photographer in San Francisco, and asked him to enlarge it. He tried to hide his amusement. I hoped he didn't recognize that I was one of the nude models. He told us kindly that our negatives were not good enough to enlarge, and that inspired me to buy a better camera, an Eastman with an F 7.7 lens and a film-pack back.

The clerk took an interest in my effort, pointing out all my mistakes, and told me to learn to judge light on my ground glass before I made the exposure. There were no exposure meters and no panchromatic film yet, so one guessed. I underexposed, I overexposed, but I improved.

On the clerk's advice, I made my own enlarger by using my camera as a projector, fitting it into an opening in an apple box, and making a reflector with a large Ghiradelli chocolate box.

It was then that I met Consuela Kanaga, who worked as a photographer on the *Chronicle*. She persuaded me to buy a better camera when she saw my equipment—a used Thornton-Pickard English reflex, 3¼ × 4¼, with a soft-focus Verito lens, which was most commonly used by the important photographers of the twenties. We roamed the city looking for bits of local color. I was discovering that San Francisco was full of photographers: Arnold Genthe, Francis Bruguierre (a member of Stieglitz's photo-secessionists), Dorothea Lange, and Edward Weston (whom we saw often).

Louise, Kairouan, Tunisia, 1928

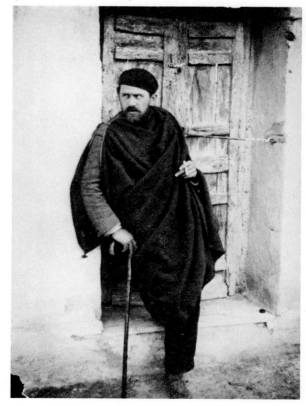

Meyer "Mike" Wolfe, Kairouan, Tunisia, 1928

6

# MY CAREER BEGINS

I left San Francisco in 1923 to study interior decorating and architecture in New York, returning a year later to become an assistant to Beth Armstrong of Armstrong, Carter and Kenyon, the top decorators in San Francisco. I loved working for her—she was creative and her taste was impeccable.

Nineteen twenty-six was a sad year. We were in an automobile accident in which my mother was killed. My sister persuaded me to leave for Europe to broaden my vision, so I left for France with friends. In Paris I bought my first movie camera, a Pathé Baby, and we filmed everything in sight. We went to Italy in the midst of the great unrest that brought Mussolini to power. One day in a cathedral in Venice I became entranced by the patterns the sun made on the floor, and started the movie camera. The whirring noise aroused the concierge, who jumped up in excitement screaming "BOMBE! BOMBE!", and we flew into the street.

Shortly thereafter we went to visit a friend from New York who was living and painting in Kairouan, the Holy City of North Africa. There I looked out of a train window to spot an American artist named Meyer (Mike) Wolfe. I just liked the look of the cut of that guy. I thought, "Gee, that's for me." He was from Tennessee, and the first

Eggplants, 1931

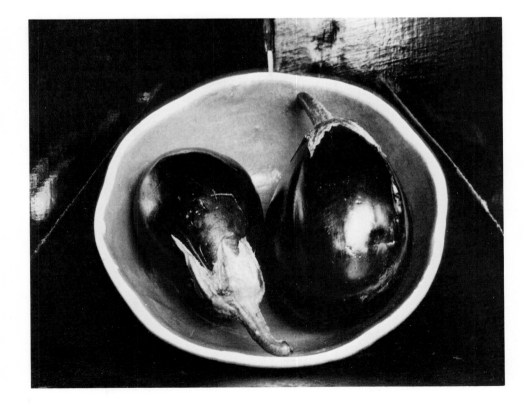

7

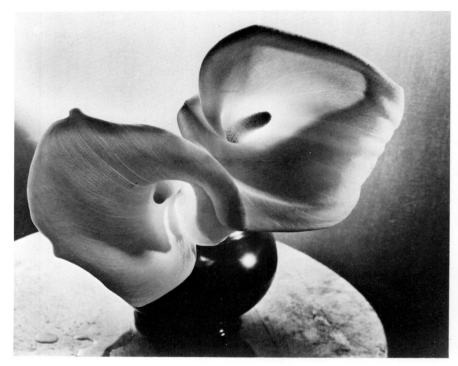

Calla lilies, 1931

Apples, 1931

8

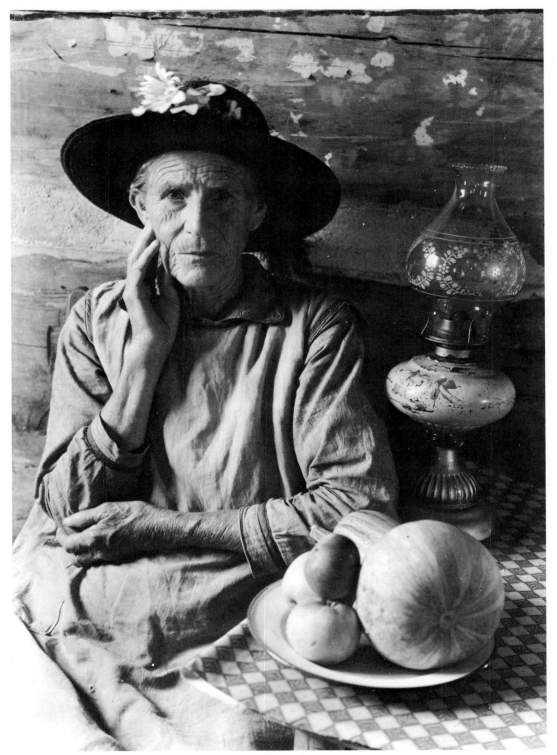

9

Mrs. Ramsey, Tennessee, 1933. This documentary photo of my Gatlinburg neighbor was published in *Vanity Fair* in 1933 as *Tennessee Mountain Woman*.

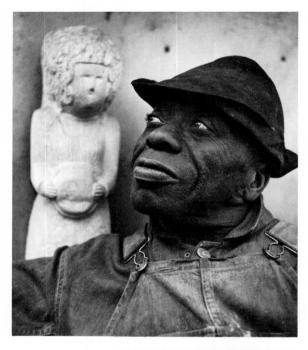

William Edmondson, sculptor, Nashville, 1933

night we met we fought over the merits of the Michelangelo ceiling in the Sistine Chapel. This was the man I've loved and have been married to for more than fifty-five years!

I began to take photography seriously, and when I returned to San Francisco after a year and a half of traveling in Europe, I bought a 5 × 7 view camera with a wide-angle lens to photo-

Hands on music, Nashville, 1932. This was in Beaumont Newhall's great show at the Museum of Modern Art, "The History of Photography," 1937.

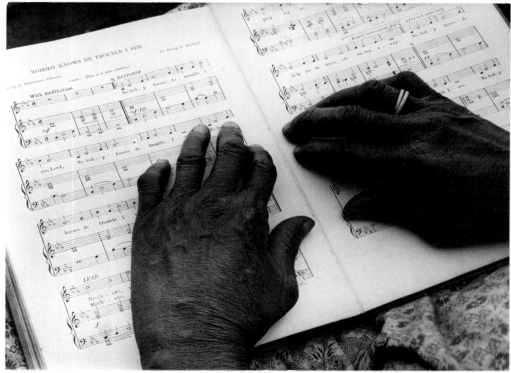

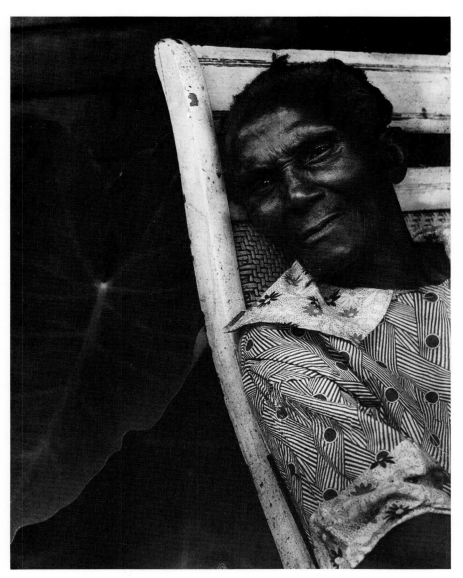

Ophelia, Nashville, 1932

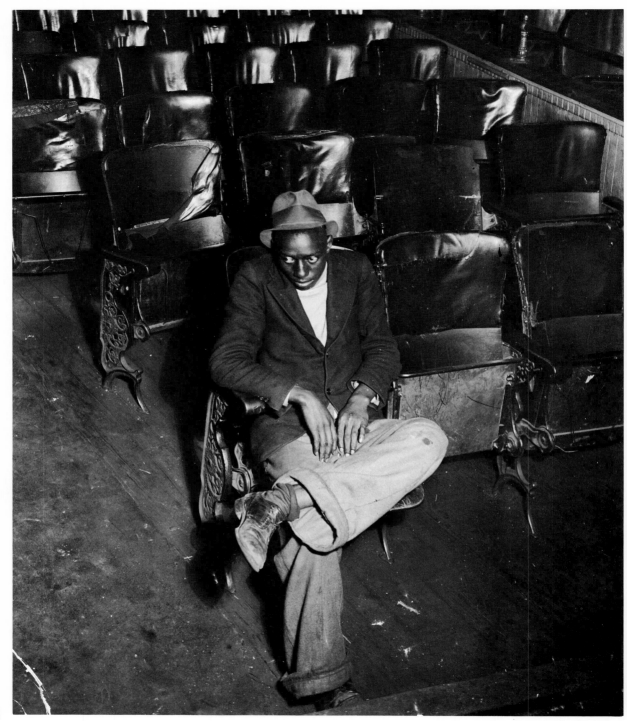

12

Negro in the theater, Nashville, 1932

graph the rooms my decorator friends were designing. Panchromatic film was on the market now, but still no exposure meter. Mike and I decided to spend the summer in the Smokies in Tennessee so he could paint there. We rented a log cabin without electricity in Gatlinburg. To develop film, we rigged up a darkroom light from the battery of a Model A Ford. I was taking pictures of the mountain folk every day.

# NEW YORK

On the day of President Franklin Roosevelt's bank holiday, Mike and I left Tennessee to drive to New York. Our friends were horrified at our daring, but we had the spirit of the young. The first shock was driving across the Jersey Meadows to reach New York City—we were greeted by miles of shacks built of tin cans and old boxes for the shelter of thousands of homeless, unemployed men. But not even the vision of people selling apples on Fifth Avenue could dampen our spirits. I was soon hired by *Woman's Home Companion* magazine to do food photographs, and we found a studio on West 52nd Street in a block of jazz joints and speakeasys. I spent hours day and night climbing up and down a ladder pushing plates of food into harmonious patterns to the tunes and shrieks of a jazz band.

Around this time, a friend of mine from art school days, Anne Wille, was doing fashion drawings for *Women's Wear Daily*. She thought it would be a good idea if an artists' agent she knew would take my Tennessee photographs to *Vanity Fair*. Mr. Frank Crowninshield, the editor there,

decided to publish my *Mrs. Ramsey—Tennessee Mountain Woman* in the November 1933 issue. I knew the magazine very well, having subscribed to it during my art school days, so this was inspiring news for me. After reviewing my Tennessee portfolio, he asked to meet me. He was very charming, and when he held out his hand to me, he said "Allow me to congratulate you—you have something." I was overcome and startled when he asked me to come and do portraits of prominent people in the Condé Nast studio for *Vanity Fair*. I thanked him but evaded the request, as I knew that I could never work in someone else's studio. I am of an independent nature and need my own surroundings. (I guess I am my father's daughter.) He then said, "If you ever need help, please feel free to call me."

Following my conversation with Crowninshield, Dr. M. F. Agha, the art director, walked in, looked over at me, and then picked up one of my photographs of a still life of apples on a plate, done in 1931. He looked me in the eye, critically, and pointed to a weak spot in the print. I felt like melting through the floor with embarrassment, as I well knew that the exposure and lighting were a failure in the shot.

Two years later, I needed advice on buying some photographic portable lights, so I telephoned Crowninshield and asked his help. He told me he would make an appointment for me to see Dr. Agha, and that I shouldn't be doing fashion work, which I had recently begun, but portraiture. The next week, when my appointment with Dr. Agha came around, I was in bed with a high fever and the flu, but I wrapped myself up in my winter wools because I couldn't afford to miss our meeting, and arrived in his office look-

13

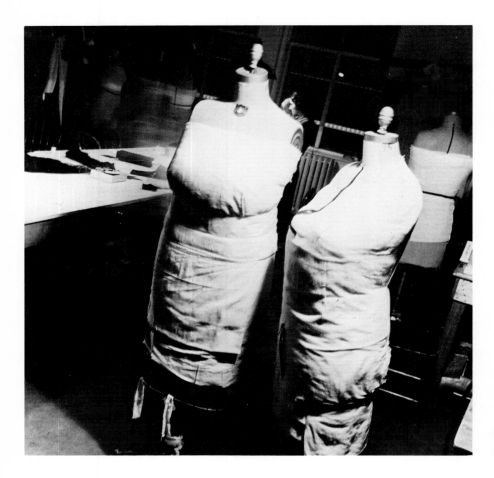

Sophie Gimbel's cus-
tomers' dummies, 1936

ing like a middle-aged dowager. Agha looked me
over, answered my questions about lights, and
dismissed me without ceremony. I fled home to
bed.

I soon began fashion work for Saks Fifth Av-
enue, under the direction of George Green, who
was tops in his field. He was a pleasure to work
for, giving me free rein through all the depart-
ments in Saks, and letting me choose my own
backgrounds. Sometime during this period I sent

Dr. Agha a portfolio of fashions, which was re-
turned a week later. As I was glancing through
it, a piece of paper dropped out that read: "This
is the work of a Louise Dahl-Wolfe who is mak-
ing a great effort to learn photography. She has
taste but on account of her advanced age—about
forty-eight—perhaps a little too late." The
memo, left in by accident, was to the publisher,
Condé Nast.

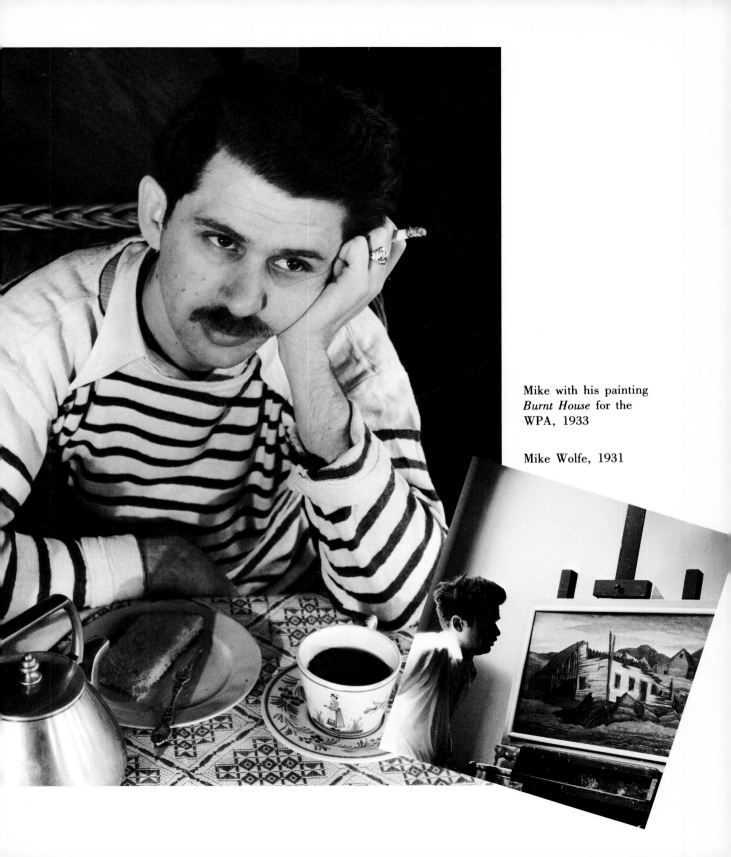

Mike with his painting
*Burnt House* for the
WPA, 1933

Mike Wolfe, 1931

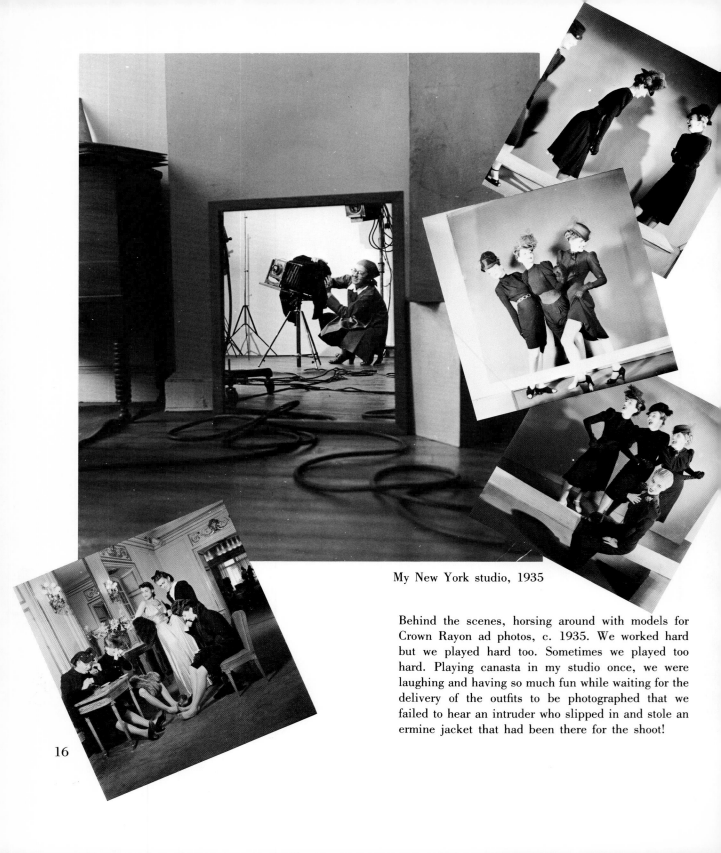

My New York studio, 1935

Behind the scenes, horsing around with models for Crown Rayon ad photos, c. 1935. We worked hard but we played hard too. Sometimes we played too hard. Playing canasta in my studio once, we were laughing and having so much fun while waiting for the delivery of the outfits to be photographed that we failed to hear an intruder who slipped in and stole an ermine jacket that had been there for the shoot!

16

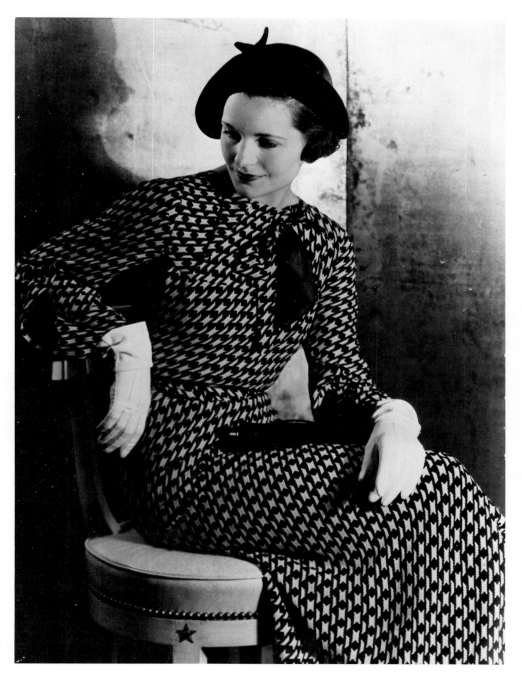

Crown Rayon, my first
account, January 1934

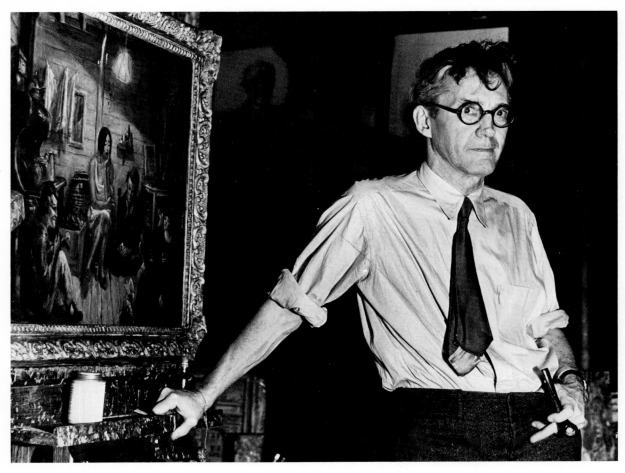

John Sloane, New York, 1933

About ten years later, long after I'd become established at *Harper's Bazaar*, the Condé Nast organization was not as prosperous as it had been. One day the telephone rang, and it was Dr. Agha, asking if he could come up to the studio to see me. We had apartments in the same building at the time, and as we were walking upstairs, he turned to me and said, "Oh, I thought you had white hair." The remark almost sent me flying, realizing that he was thinking of the memo writ-

ten to Condé Nast ten years before. I managed to control my amusement. After some small talk, he told me that his reason for coming was to ask me whether I would leave the *Bazaar* and come to work in the *Vogue* studio.

My work in color was popular with some of the advertising agencies at the time, particularly J. Walter Thompson. I had received the Art Directors Club medal of merit for Crown Rayon color photographs. J. Walter Thompson asked me

to give up my other advertising accounts and be on a forty-thousand-dollar retainer to work exclusively for them (excepting my work for the *Bazaar*). However, with my independent nature, I had to refuse him, as I refused Dr. Agha, too.

Some years later my assistant, Alfred Linn, found the copy of Dr. Agha's famous memo to Condé Nast. I asked Alfred to make a copy for me, and I sent it with a note and some flowers to Dr. Agha, welcoming him as he had just moved to our neighborhood. A photographer friend conveyed the news to me that Dr. Agha had read the "memo" and my note over lunch to the art director Ruzzie Green and to Edward Steichen, and they all had a great laugh. A few days later Dr. Agha telephoned and said, "Let's us old folks have lunch together."

If I had been left to my own devices, what I would have wanted to do was still lifes and portraits. And when I was starting out I certainly knew nothing about fashion photography. But then, neither did anybody else. Fashion was being illustrated by artists; but since fine artists were rare in the field, in the thirties they were beginning to be replaced by photographers. A friend of mine suggested I try my hand at fashion, and another friend who worked at Milgrim's on 57th Street offered to let me use her showroom models and the clothes in exchange for which I was to give her photographs she could use on the women's pages of newspapers. That was the best training I ever had. Those girls were at least forty years of age. I practiced lighting on them, to get them to look chic, elegant, beautiful, and yet natural—and that took work. My first true advertising account was Crown Rayon, a division of

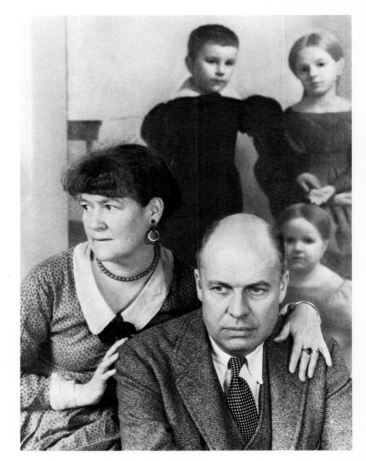

Edward Hopper, New York, 1933

the Viscose Corporation. In 1934 they were paying good money for Depression times, a hundred dollars for one advertisement a week. The dresses they sent were black crepe with white collars, cuffs, and accessories. The extremes in these tonal values led me to badly overexpose the whites. Outdoors was very difficult. In the studio I could control the light and exposure better. By the end of 1934 the Weston exposure meter was available and my troubles were over.

19

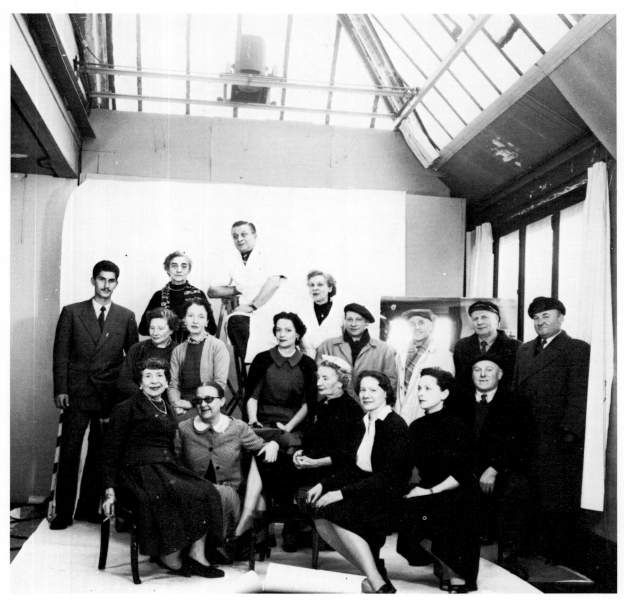

*Harper's Bazaar* staff in Paris, 1956

20

# WORKING AT *HARPER'S BAZAAR*

I was to begin my long career at *Harper's Bazaar* in 1936. Over the years, they published more than 600 photographs of mine, as well as 86 covers and thousands of black and white pictures. From 1937 on, when I did my first color for them, I corrected all my own proofs. By and large, most color photography was pretty mediocre at the time, with the exception of the work of Anton Bruehl, who worked for *House & Garden* and *Vogue*. I started with still lifes and accessories (I did shoes until they were coming out of my ears!), but I wanted to work with people and within a year I was doing portraits and fashion.

*Harper's Bazaar* in those days was so wonderful. The magazine was in the hands of the greatest magazine editor ever, the magic Carmel Snow. I felt fortunate to be working under her direction. She trusted her editors and artists completely, and fought commercial interests to produce a magazine of quality. Alexey Brodovitch was the art director. He never interfered with my work either. He always told me in advance which pages would face one another, and that's all I needed to know. Diana Vreeland was *the* fashion editor. Frances McFadden was managing editor, and George Davis was literary editor. Under Carmel's sponsorship the great new young writers of the era, like Carson McCullers and Eudora Welty, were published, and I had the opportunity to do their portraits. Carmel had the most darling sense of humor. I sparred with her but she was imaginative and protective. She was responsible for making the *Bazaar* in those days much more interesting, and less conservative, than *Vogue*. People say I was demanding,

21

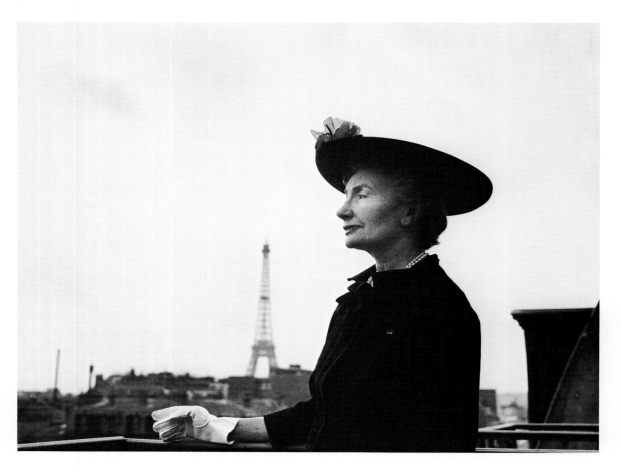

Carmel Snow, 1940s. ". . . what made Carmel a great editor: one of her talents was her ability to absorb impressions quickly (she was always in a hurry) yet accurately (with devilish accuracy in some cases). She knew where every seam in a dress was placed without feeling it . . . she could walk into a room once and tell you everything important in it. Her intuition was particularly keen with people. She saw beauty before the fledgling herself realized she was going to be beautiful . . . and cleverness just by looking into a pair of eyes. . . .

She could move from one milieu to another without confusion. In twenty-four hours in Athens, Carmel experienced Greece because she was able to put out of her mind other things and concentrate, not on a guide book, but on her own feelings for this new place, these new people, this great building, this Parthenon. . . . In her younger days she was in love with everything . . . with her children, her magazine, her religion, her new hats, her husband Snowy. . . ."

—Frances McFadden

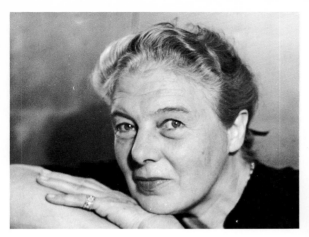

Frances McFadden, managing editor, *Harper's Bazaar*, 1938

Carmel with Christine Holbrook, her sister, editor of *Better Homes and Gardens*, 1940s

George Davis, literary editor, *Harper's Bazaar*; Alexey Brodovitch, art director; and Diana Vreeland, fashion editor, 1943

23

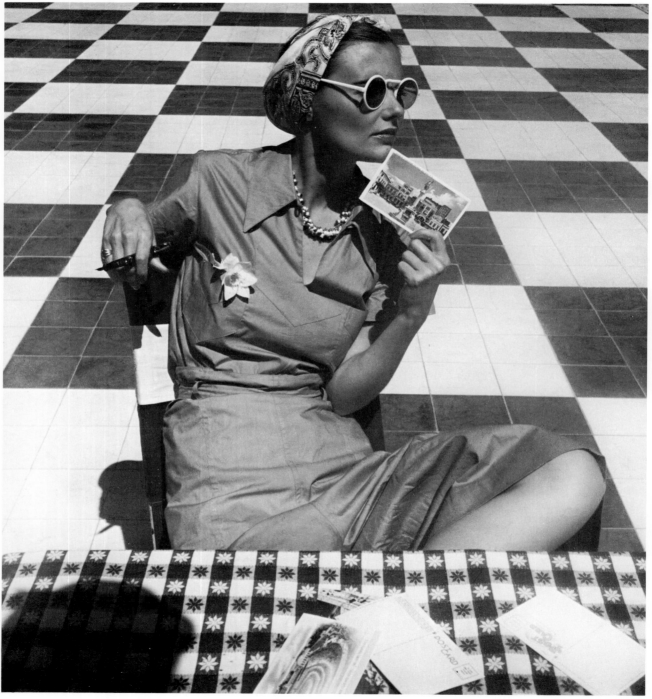

24

Mary Sykes in Puerto Rico, 1938

and I guess I did drive my models hard. I was teased by my models for saying "Hold it! Hold it!" all the time. I suppose I stormed a lot, but in the end, we'd all have a drink together.

Turkish promotion shot, 1952

Going over contact prints with Carmel Snow, Paris, 1953

Everyone helps prepare a Turkish set for shooting; *left:* Patricia Cornwell, a fashion editor; *second from left:* Mary Jane Russell, model, 1952

Diana Vreeland, 1942

"*Louise was passionate, more ignited by her métier than anyone I have ever known. She was a great experimenter—but once her decision was made she was very positive. She was one of the first to use daylight lighting for fashion photography, a pioneer in color and daylight. She was great to work with—she's always had a contagious spirit.*"

—*Diana Vreeland*

Diana Vreeland with model Bijou Barrington, Arizona, 1942

26

André Gremela with model, Canary Islands, c. 1953 (my Paris assistant who had worked with Baron de Meyer, Edward Steichen, George Hoyningen-Huene, and Richard Avedon)

Liz Gibbons, Cuba, 1941

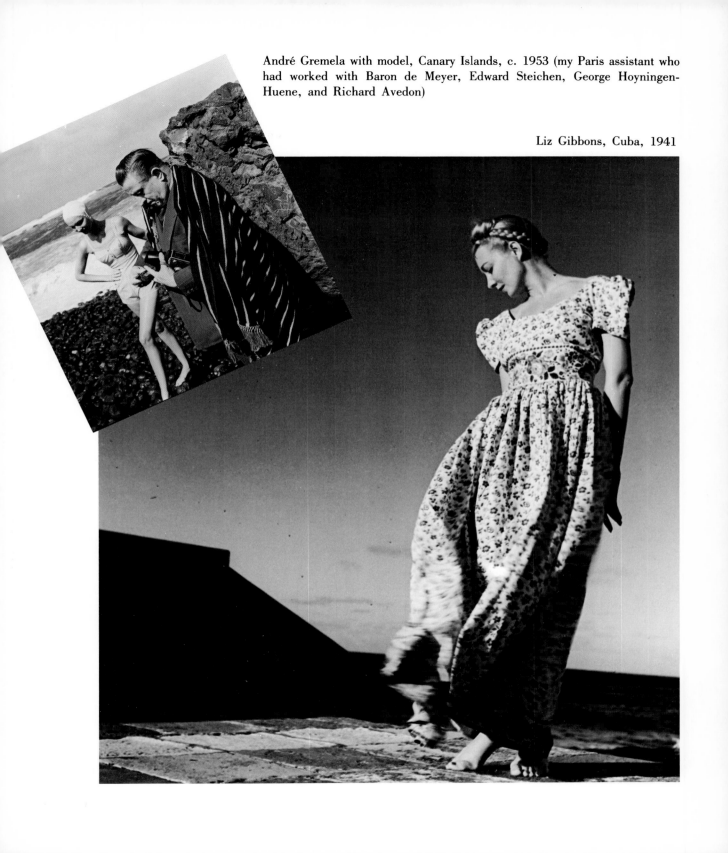

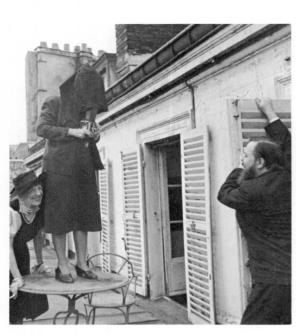

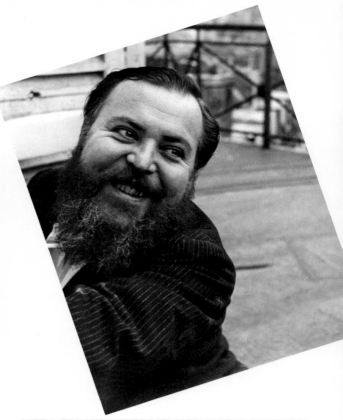

Taking Christian (Bébé) Bérard's portrait, Paris, 1946. I had to stand on a table to get the angle I wanted.

*Above right*
Bébé Berard, Paris, 1946

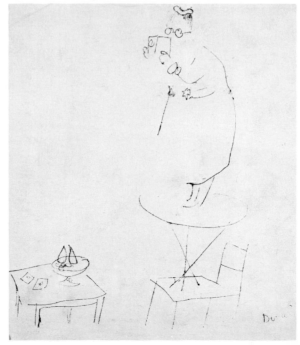

Bébé's sketch of me photographing him, made years later while lunching with Carson McCullers, 1945. He had gotten such a kick out of my standing on the table, he never forgot it.

28

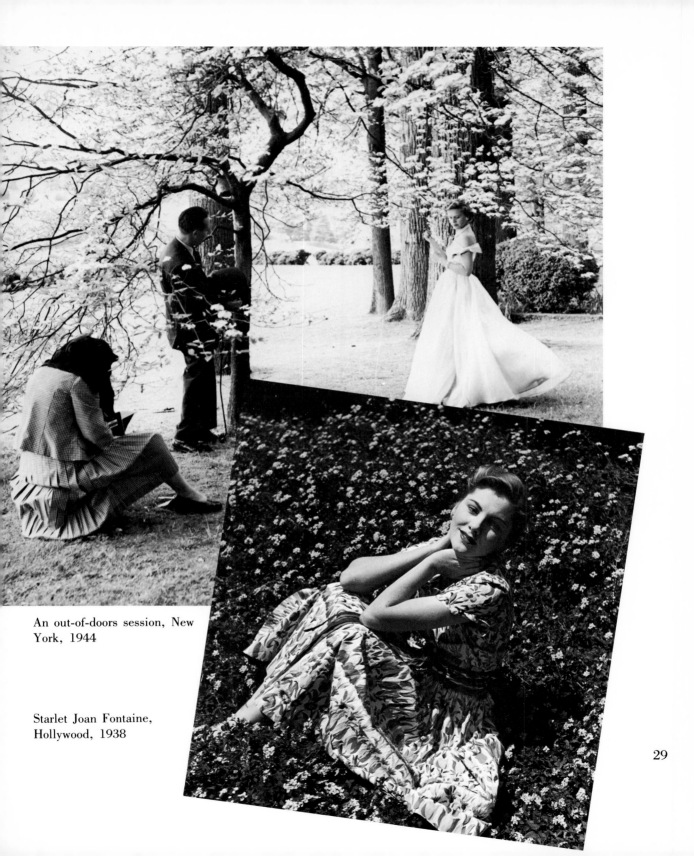

An out-of-doors session, New
York, 1944

Starlet Joan Fontaine,
Hollywood, 1938

29

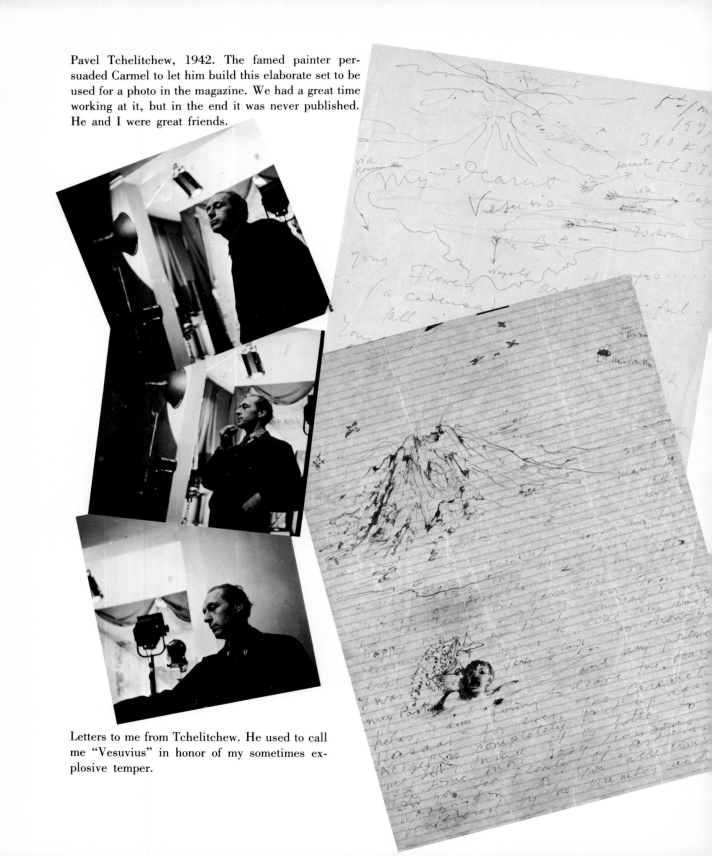

Pavel Tchelitchew, 1942. The famed painter persuaded Carmel to let him build this elaborate set to be used for a photo in the magazine. We had a great time working at it, but in the end it was never published. He and I were great friends.

Letters to me from Tchelitchew. He used to call me "Vesuvius" in honor of my sometimes explosive temper.

Best wishes for the New 1942 year! Love Pavlik!

P.P.S. I loved your portrait with no clothes on!

P.P.P.S and also the one of Joseph!!!

Dearest "Vesuvio" —
look what came out of the first bubble of your champagne bottle
love Pavlik

eyes straight from heart to heart.

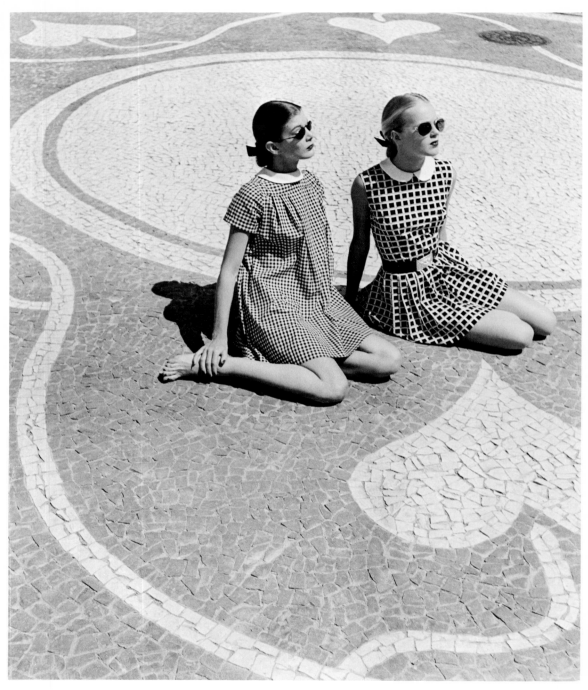

32

Mosaic courtyard, Brazil, 1947

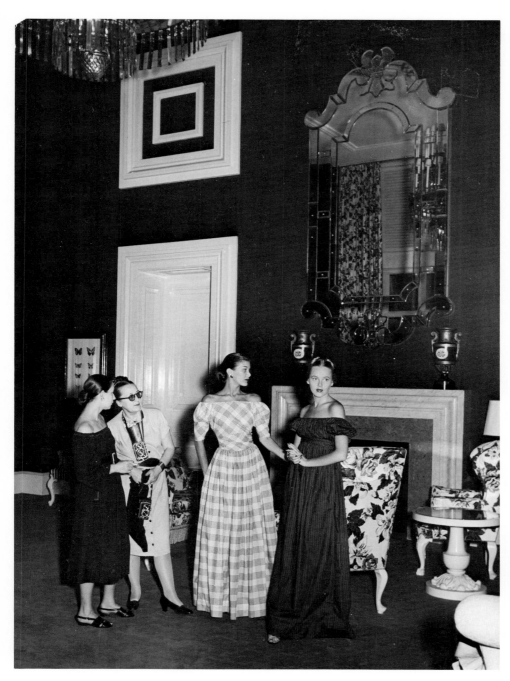

In Brazil with fashion
editor Babs Simpson
and model Bobbie
Monroe, on a Claire
McCardell shoot,
1947. Doing fashion
for *Harper's Bazaar*
took me all around
the world.

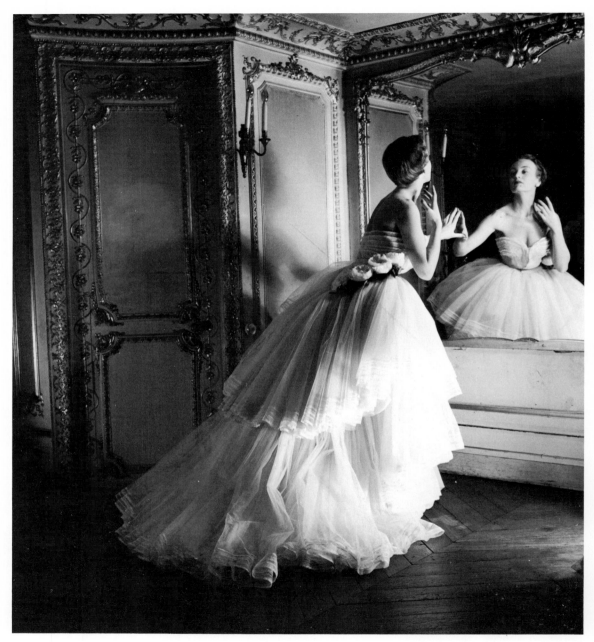

Ball gown, Paris, Dior, 1950

34

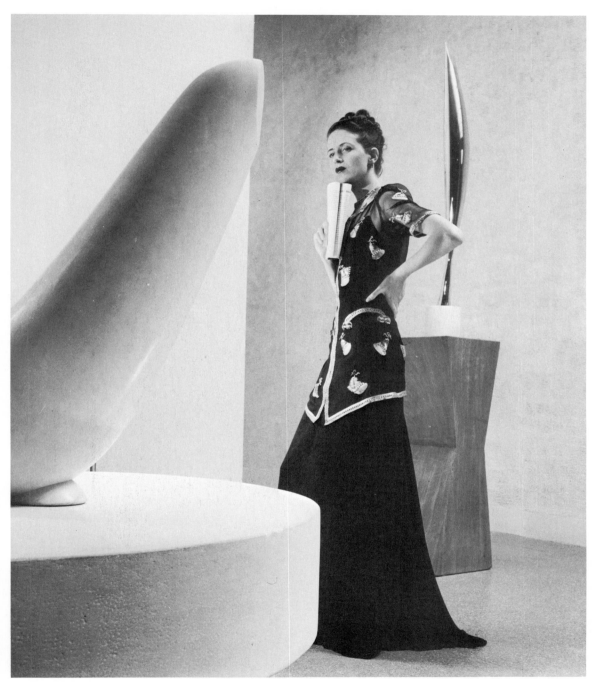

Model with Brancusi sculpture, Schiaparelli's Tunic Dress, Museum of Modern Art, 1938

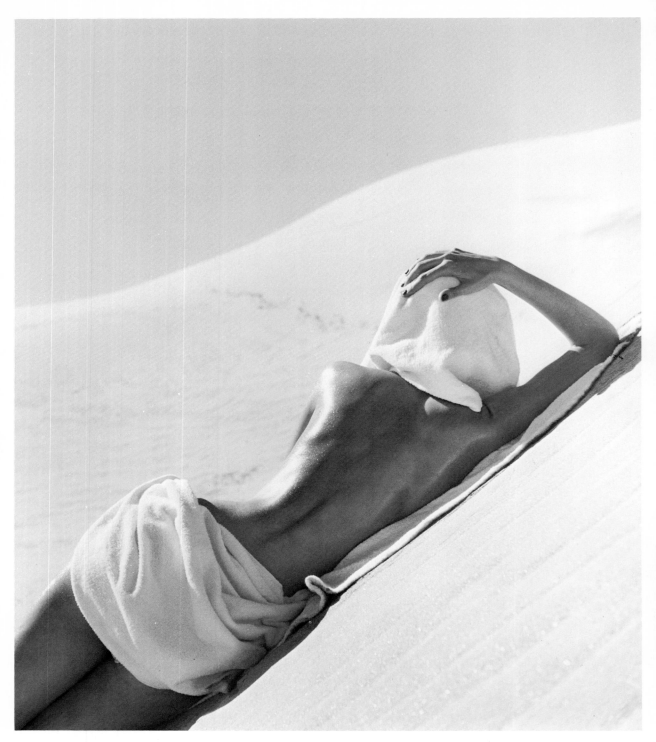

California desert, 1948. I stole the chance to portray nudes wherever I could. This was actually a fashion shoot for bathing suits, but I got the model to pose nude for me; she had to put the towel around her head against the burning heat of the Mojave.

Harry Easton, my assistant, on the scene, 1955. This is how cold it was!

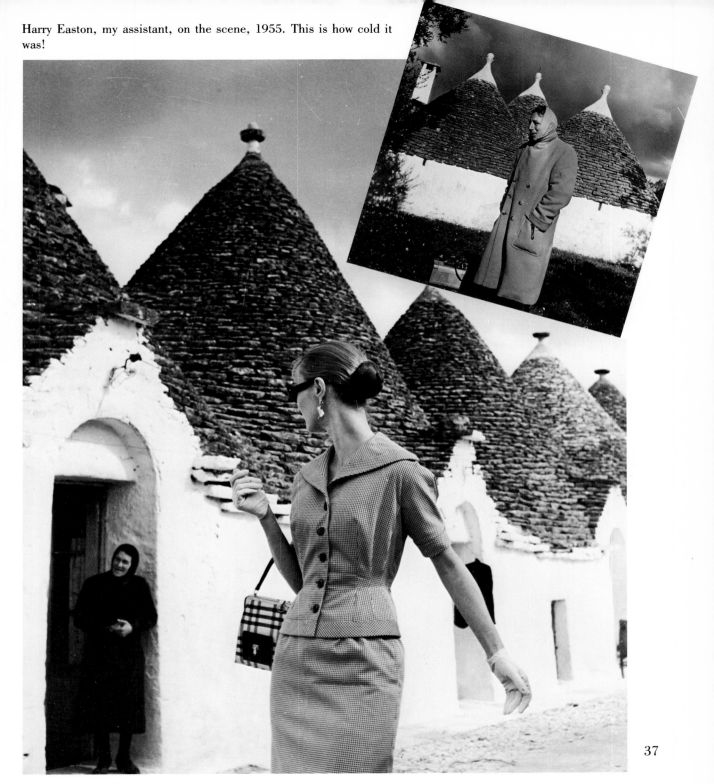

Evelyn Tripp in Gjoia del Colle, Italy, 1955. The odd-shaped houses are called *trullis*. I composed this photo around a "pearl of little price," our name for the dress of a third-rate designer.

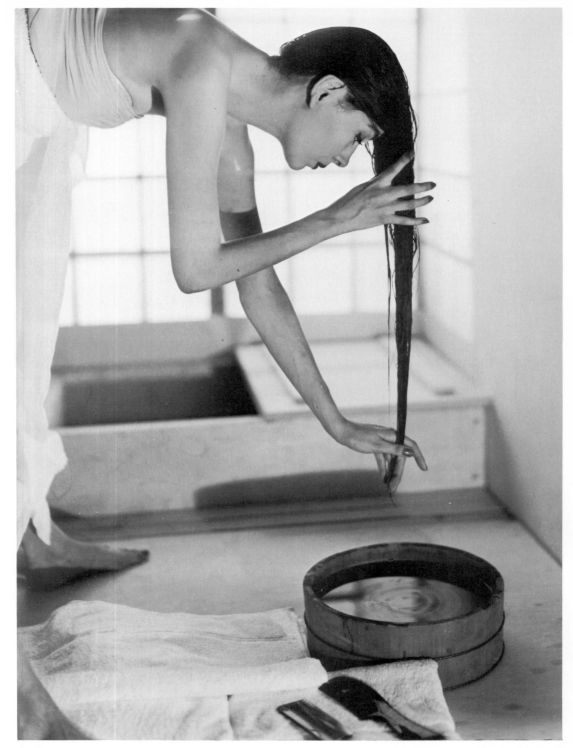

38

Japanese bath, 1954. We reproduced in my studio the Japanese bathroom at the Museum of Modern Art.

# FASHION

I was much more interested in painters or looking at a Degas than I'd be looking at most dresses done by third-rate designers. There were not many talents like Claire McCardell or Vionnet, who invented the bias cut. A fashion photographer is not a free agent—you must try to express in the photograph what the designer is saying without being literal, corny, or unnatural. What kills me in fashion photographs today is when a body is twisted unnaturally to show both the front from the waist up and the skirt from the side, a real contortionist's pose, and when models in pants are posed sitting with their crotch facing the camera and their hands dangling between their legs, like men.

I had a lot of ideas about color, too. Men, unless they work in the arts, have a pretty standard sense of color: red—or red and green. I fought red like crazy, especially in skin tones, preferring greeny-yellow complexions. My art school experience made it natural for me to experiment in color arrangement, and the new Kodachrome film made it possible.

Fashion editors are of great importance before the photographing begins. If they have an eye for color, style, form, taste and individuality, they can pull together a ready-made dress in no time at all. Very few of them have the oustanding creativity of a Diana Vreeland. She was tops on a sitting. You would be given a dress to do and you had to make a picture. The shape of the dress did not please; there would be nothing about the garment that had even a touch of inspiration; you'd be disgusted—and then you'd appeal to Diana to help brighten up the dress, and her eye would come to the rescue. She'd always produce

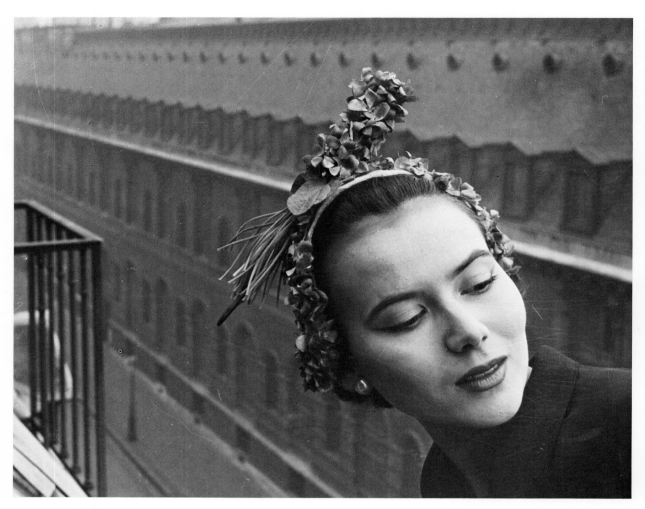

Hat by Paulette, Paris, 1950

Mary Jane Russell in Dior swan hat, Paris, 1949

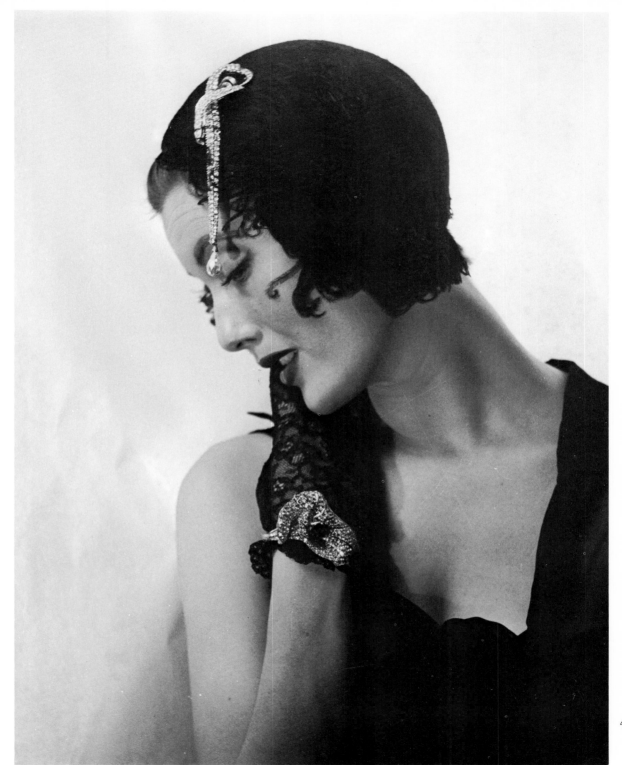

41

42

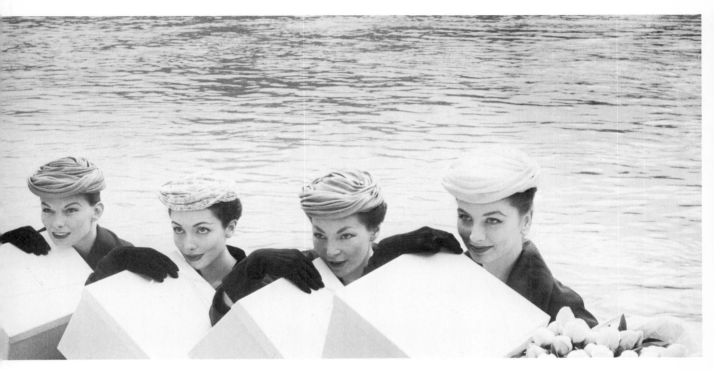

Dior hats by the Seine, 1953

Lisa Fonssagrives in Hattie Carnegie's King Tut Hat, 1945

something, like the addition of a scarf, to help liven up your photograph. Sally Kirkland, with whom I worked on some assignments for *Life*, was a genius too. Her sparkle and encouragement kept you at the task, and often saved the day. Sometimes, though, when commissioned to do a fashion or beauty shot that I found thoroughly uninteresting, I'd call Carmel Snow and howl, and she'd say, "Oh, dear, just make a beautiful picture, put just part of it in and that will be fine." The credit line was the most important of the many things you had to photograph that were unphotogenic.

The Red Cross *Harper's Bazaar* cover that sent the young model to Holly-wood for her first screen test, March 1943

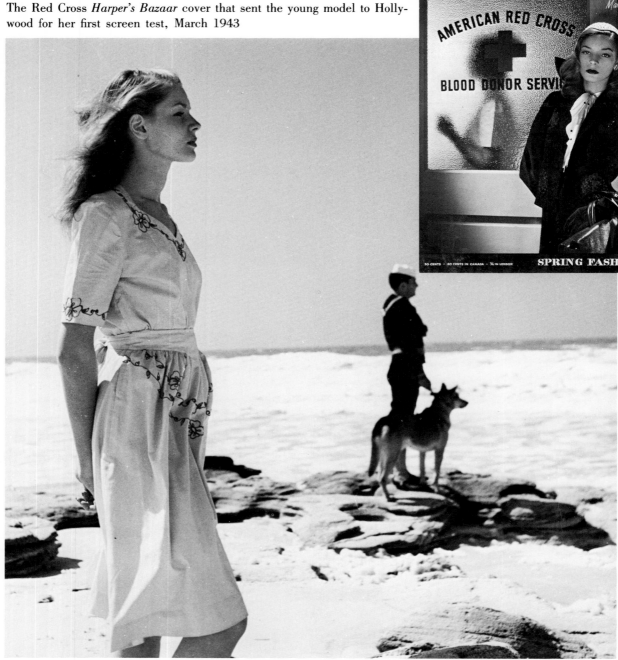

Young Lauren Bacall, 1943

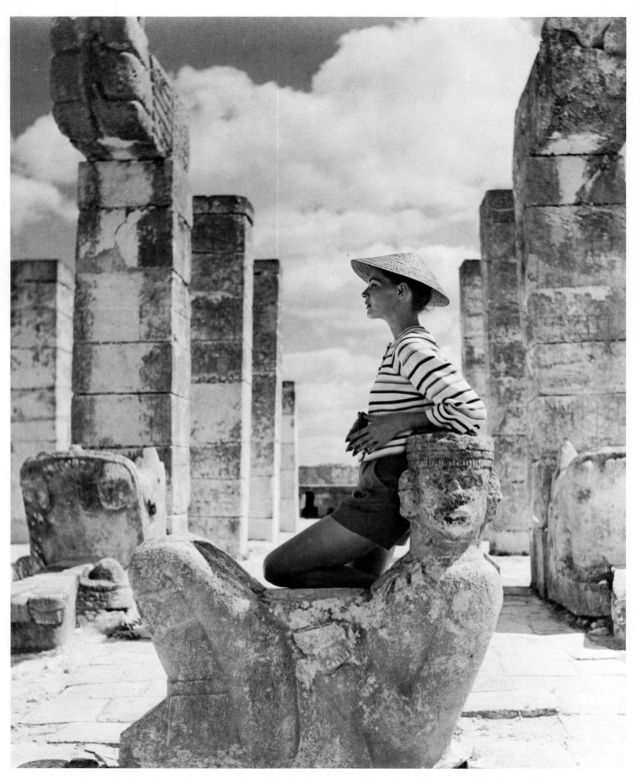

Georgia Hamilton sitting on Chac-Mool, Temple of Warriors, Yucatán, Mexico, 1952

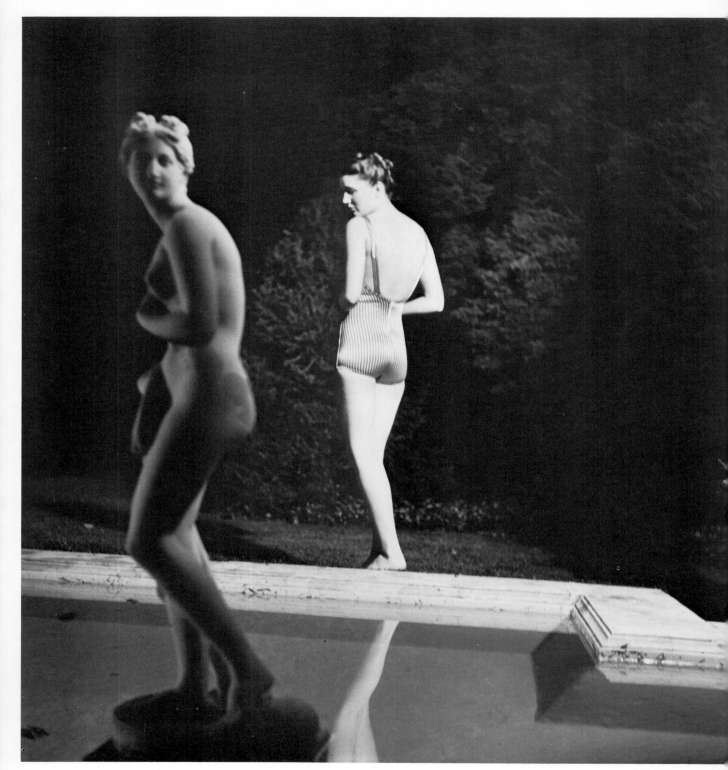

Night bathing, 1939. Model is Miggie Minnegerode.

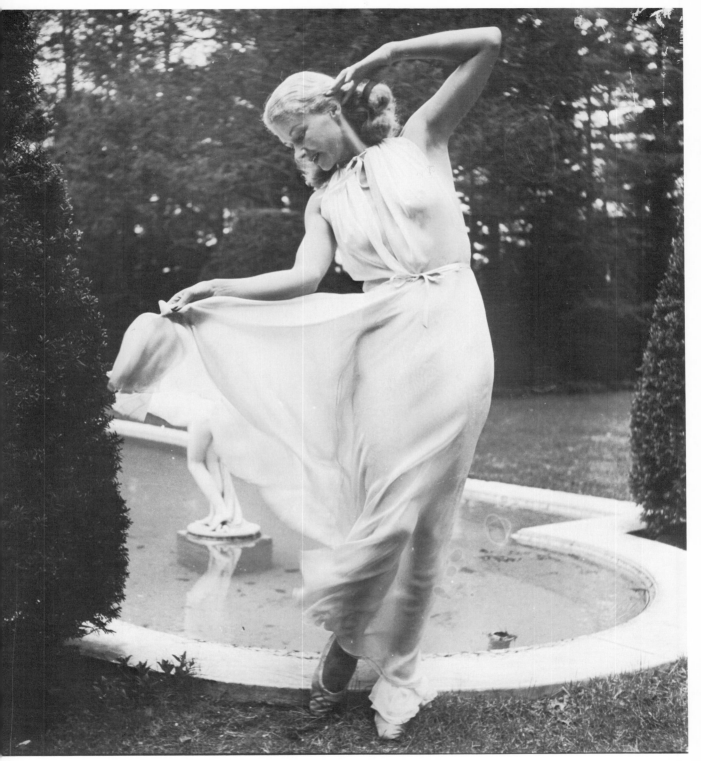

Lisa Fonssagrives at Wendy's pool, 1945

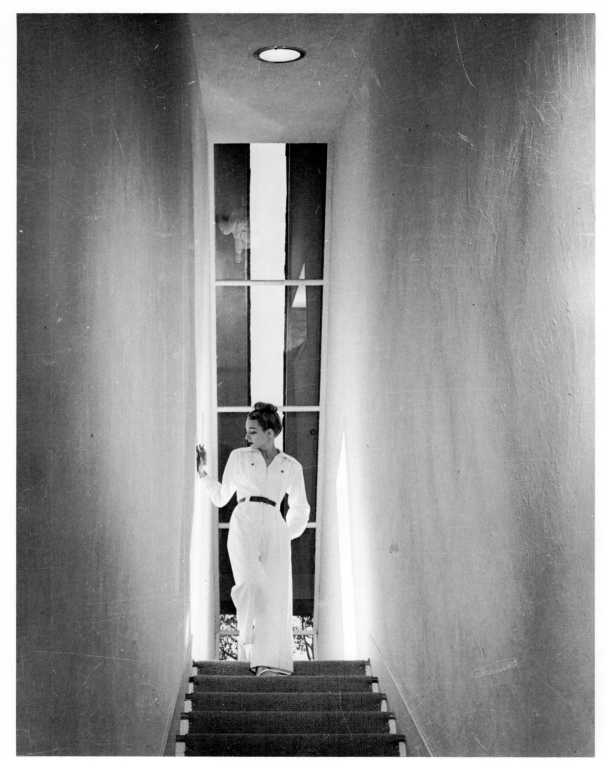

Liz Gibbons at The Creamery, 1940

Lizzie Gibbons, reflection, 1941

*"I adored posing for her. She was the* only
*photographer who gave her model the opportunity*
*to become a great actress, dancer, femme fatale,*
*and the world's reigning beauty. Her running*
*praises were head-turning and believable. . . .*
                              —*Elizabeth Gibbons-Hanson*

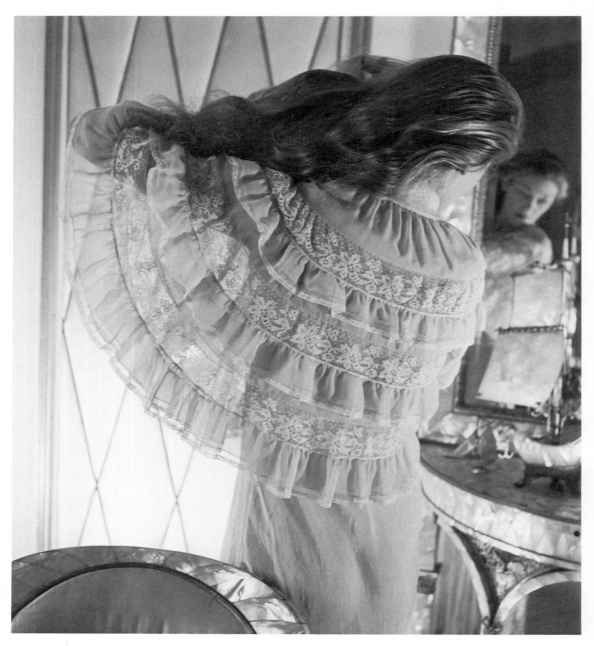

Lud, Paris, 1946, Pacquin's frilly capelet

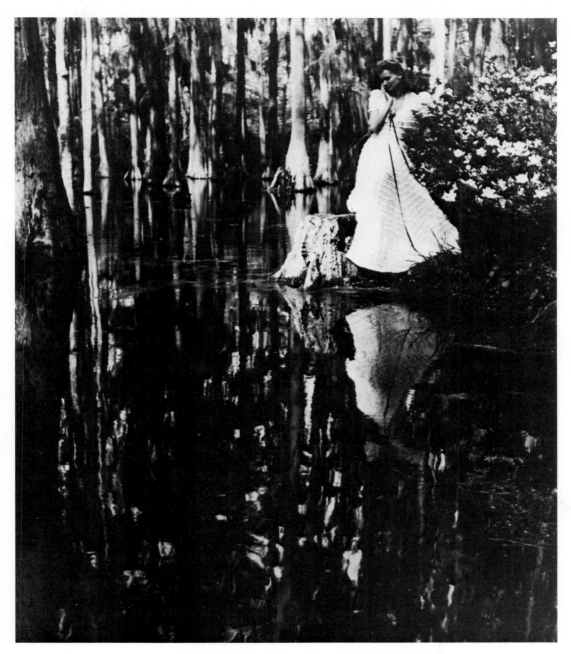

Ann Keeble, Charleston, South Carolina, 1939

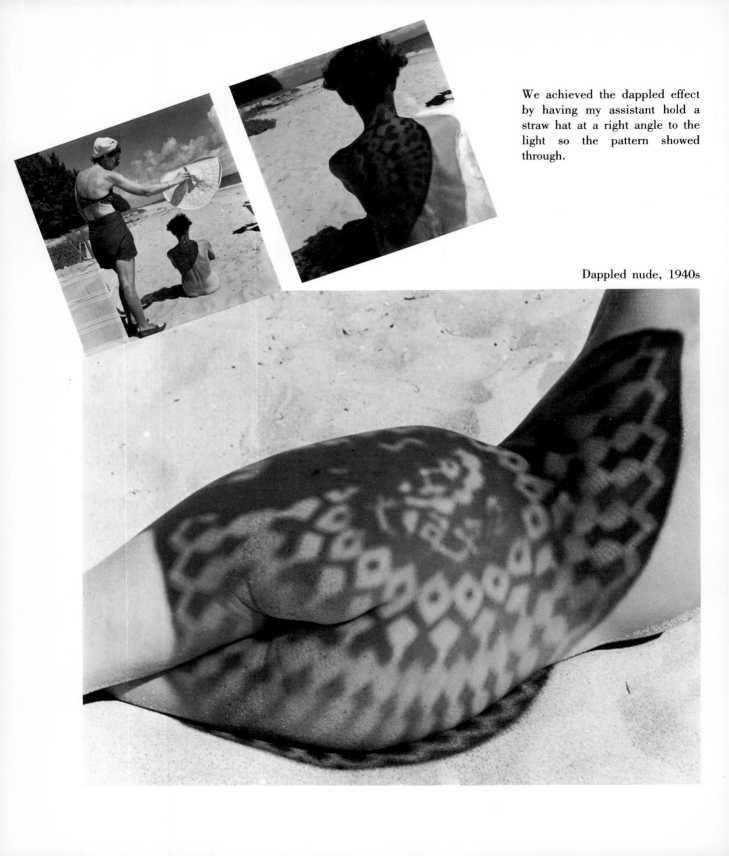

We achieved the dappled effect by having my assistant hold a straw hat at a right angle to the light so the pattern showed through.

Dappled nude, 1940s

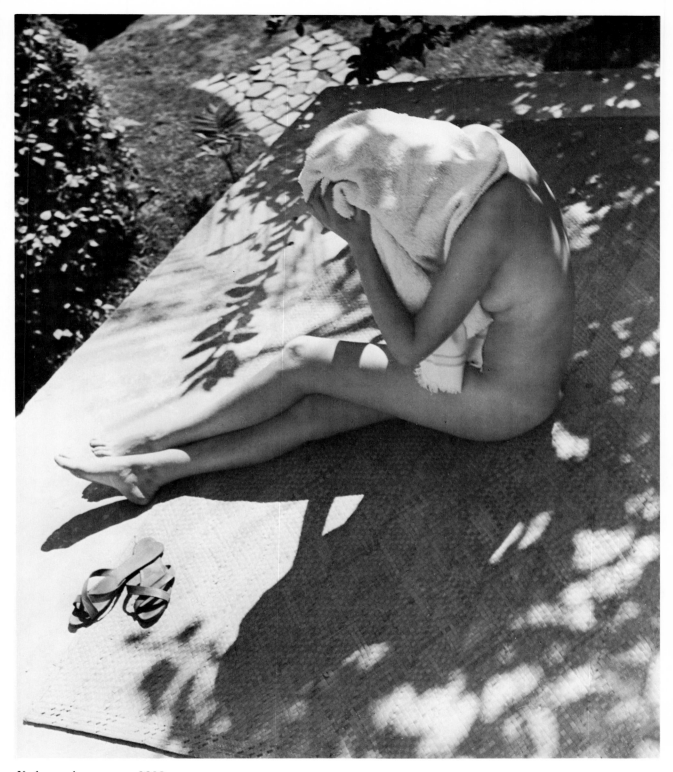

Nude on the terrace, 1938

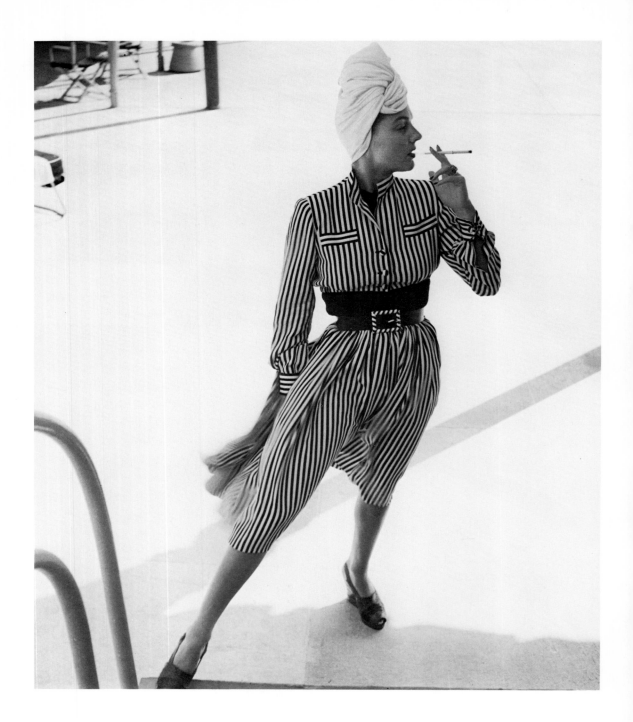

54

*Opposite*
Lady Margaret Strickland, 1939

Suzy Brewster, Miami, Florida, 1941

Wanda Delafield, Frank Lloyd Wright House, Phoenix, Arizona, 1942

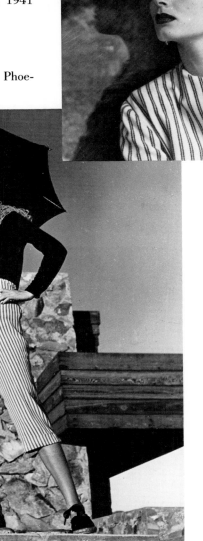

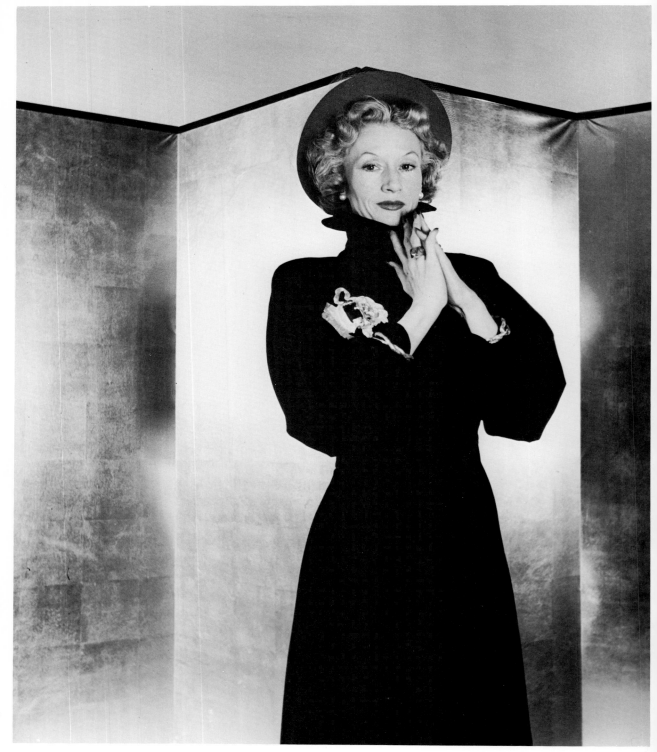

Society woman Millicent Rogers, 1946. Designer was Charles James. She was the chicest ever!

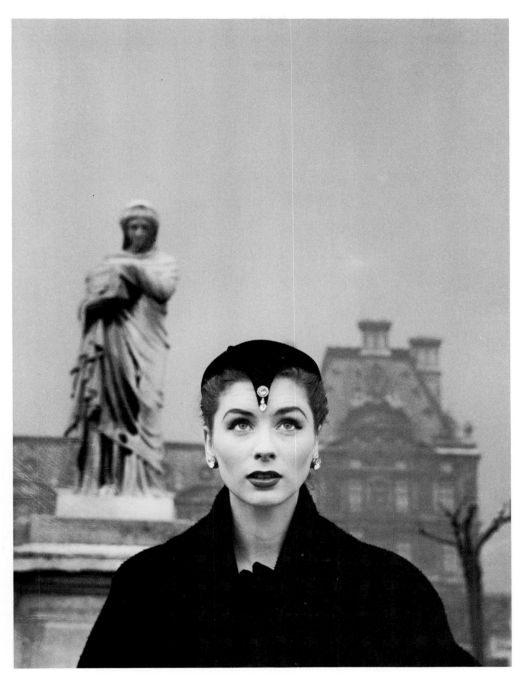

Suzy Parker in Dior hat, Tuileries, Paris, 1950

57

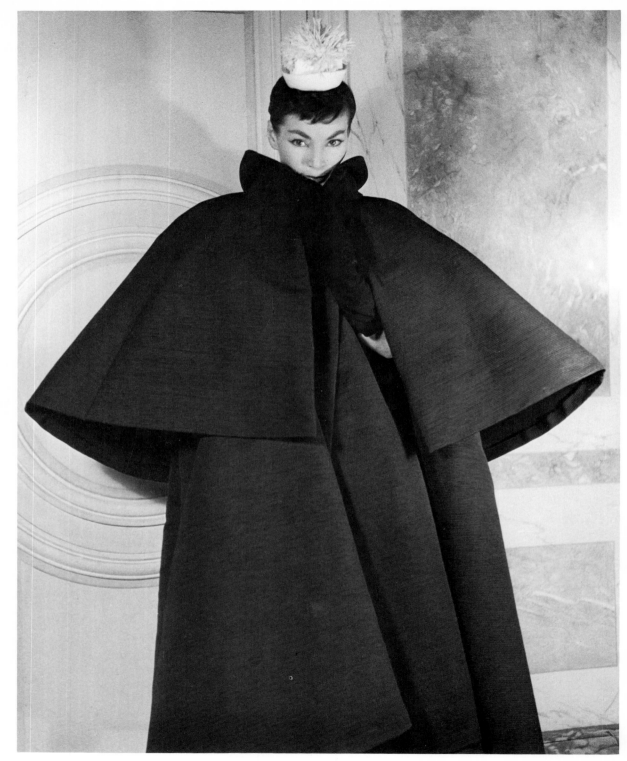

Luki in Balenciaga coat, Paris, 1953

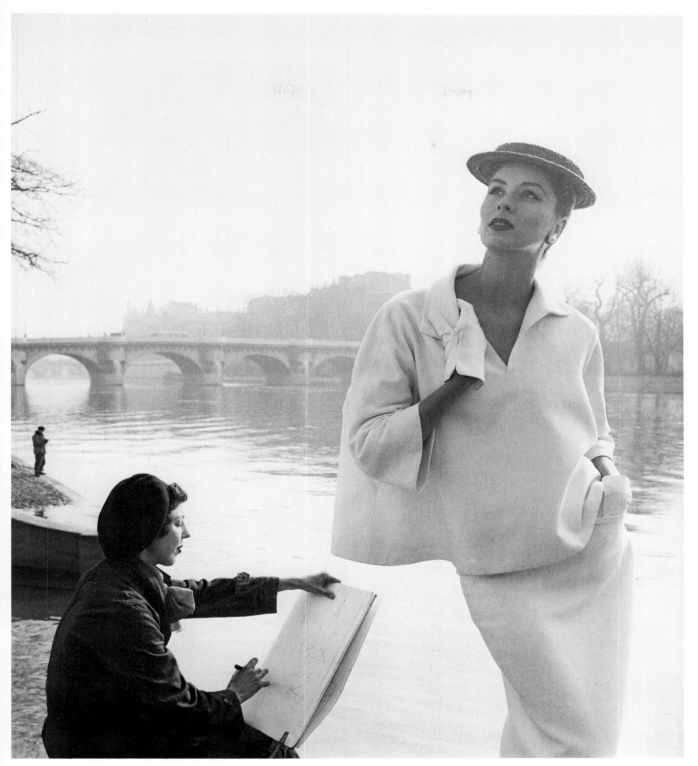

Suzy Parker by the Seine, costume by Balenciaga, 1953. Artist is Betty Fenn.

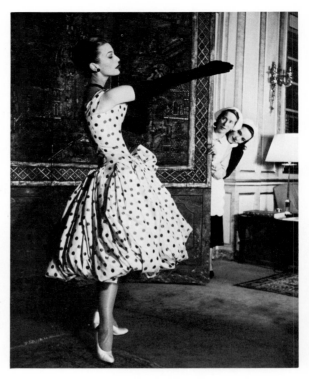

Mary Jane Russell in Dior dress, Paris, 1950

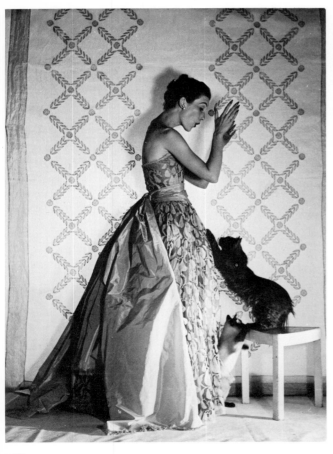

Mary Jane Russell in a Balenciaga gown embroidered
with beads, Paris, 1951

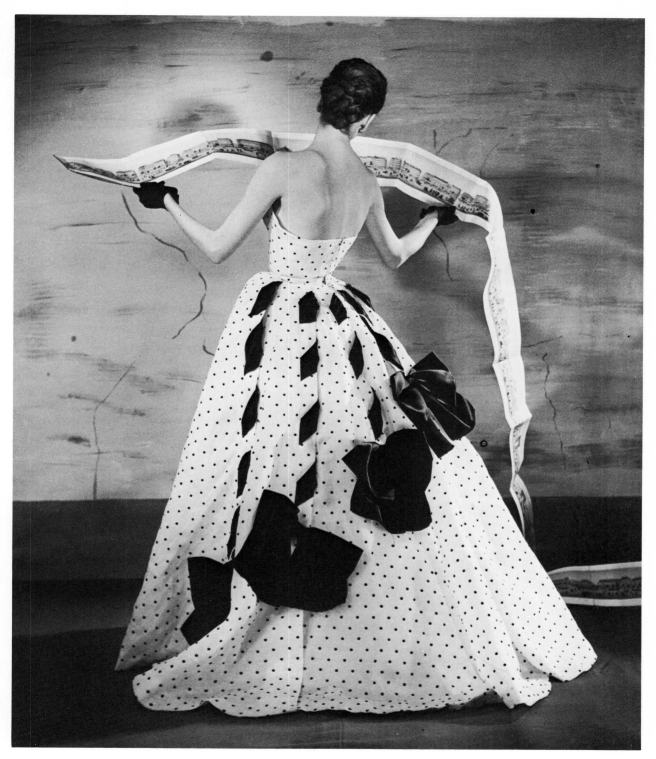

*Panorama of Paris*, Suzy Parker in Jacques Fath gown, 1953

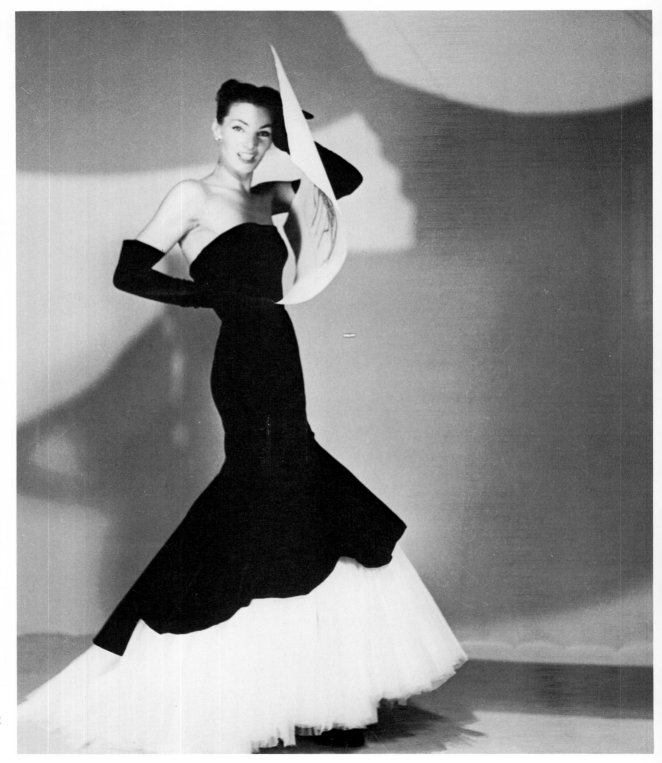

62

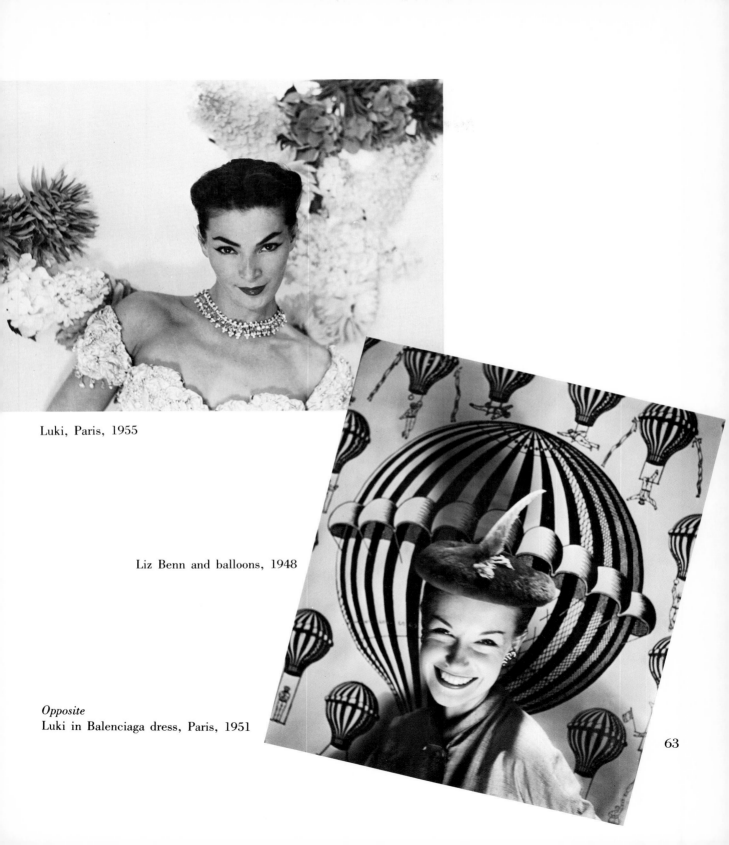

Luki, Paris, 1955

Liz Benn and balloons, 1948

*Opposite*
Luki in Balenciaga dress, Paris, 1951

63

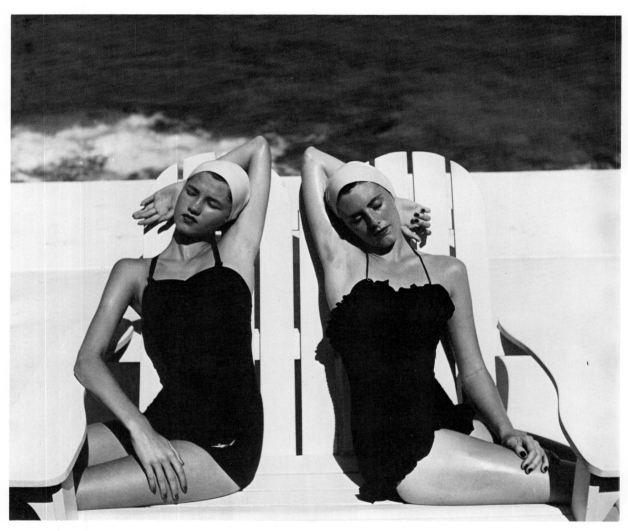

Twins at the beach, 1955

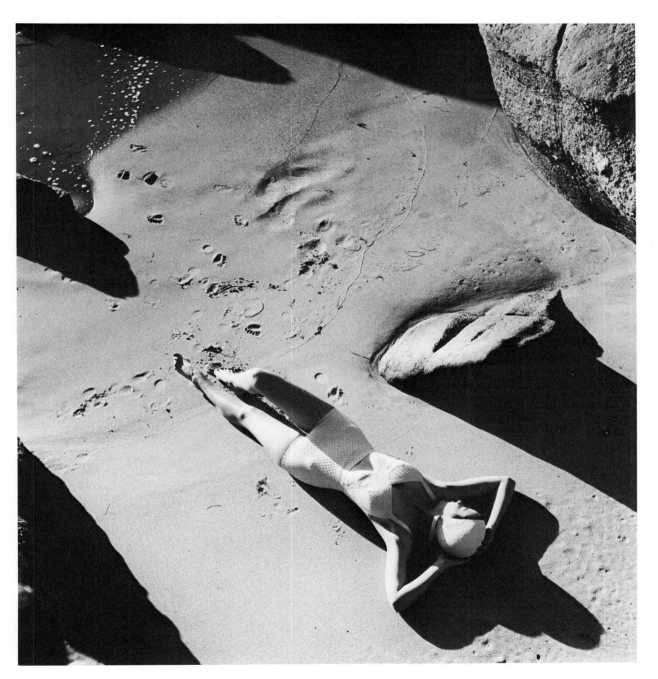

Rubber bathing suit, California, 1940        65

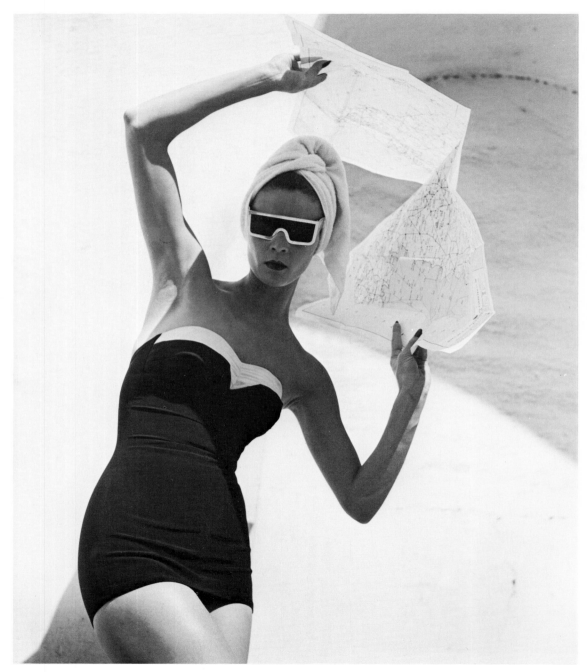

Jean Patchett in Granada, Spain, 1953

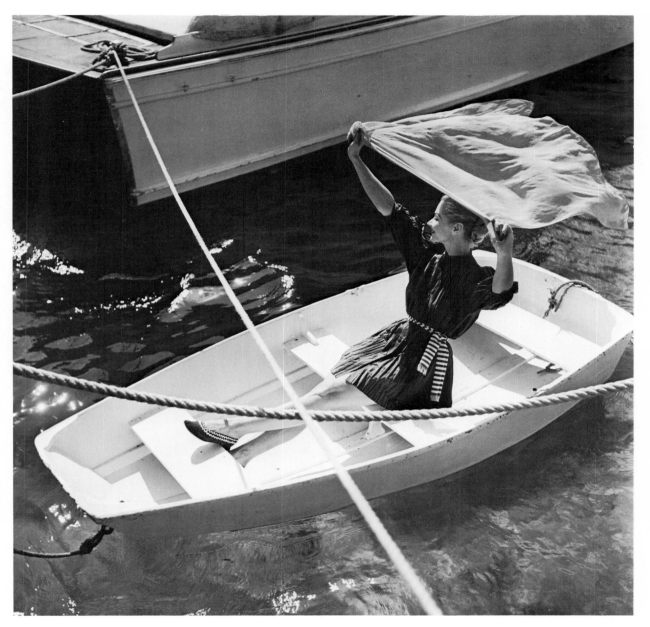

Lisa in the boat, 1955

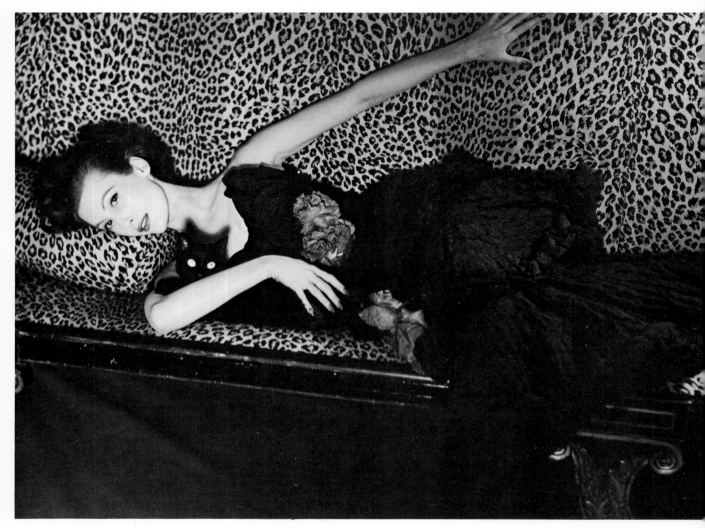

Mary Jane Russell on leopard sofa, Paris, 1951

"One was never selfish with Louise. There was an extraordinary, immediate communication of her conscientiousness, her seriousness. She was wicked, challenging, exasperating, and heavenly. It was a rare, rare, extraordinary experience. She was the most beautiful person in my working life."
—Mary Jane Russell

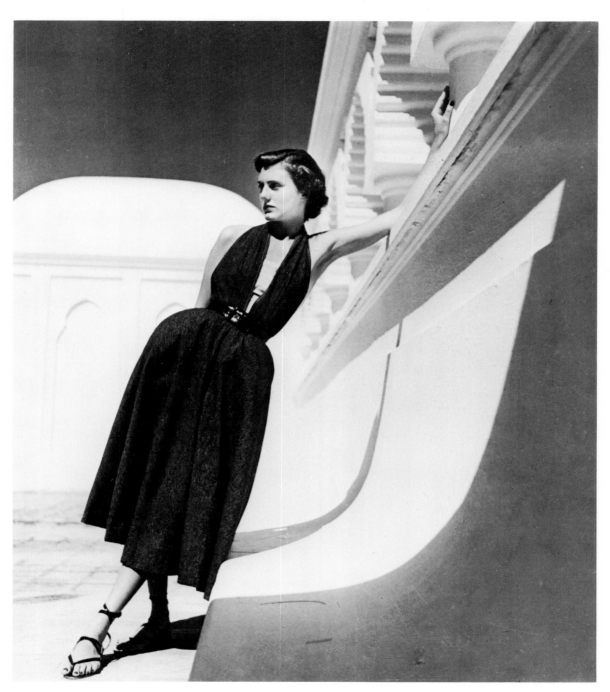

Halter dress by Brigance, 1954, Palm Beach

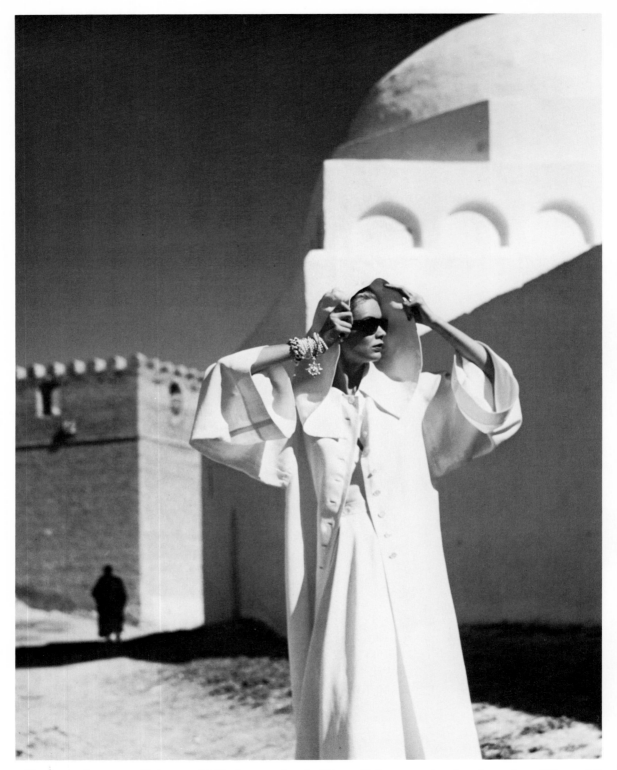

Natalie in Grès coat, Kairouan, 1950. I never thought I'd see Kairouan again, the place where Mike and I met, but a shoot brought us here.

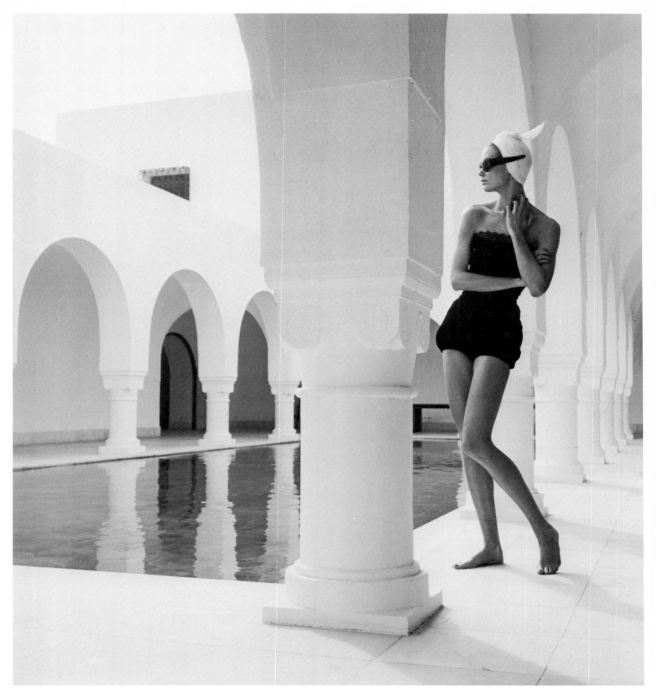

Natalie in Hammamet, 1950, suit by Howard Greer

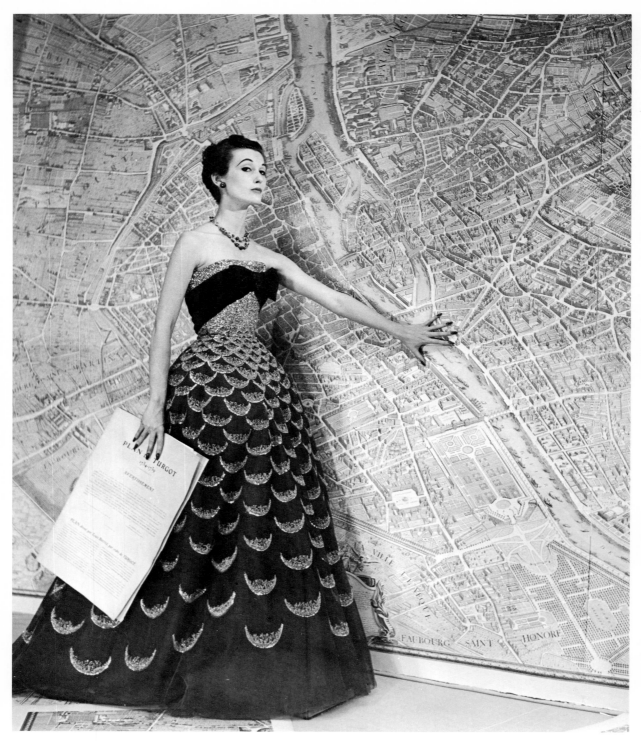

*Plan de Paris*, Mary Jane Russell in Dior dress, 1951

# THE COLLECTIONS, THE DESIGNERS

The skeletal staff in Paris was expanded each season (spring and fall) for the collections. I would come with Carmel, and it was there that I had the assistance of André Gremela, who had worked with many of the greats—de Meyer, Steichen, Hoyningen-Huene, and Avedon. Although I have several favorite American designers, the French are the ones who really know how to design clothes. After spending the day at the shows deciding what to shoot, we generally photographed at night, because that was when the models were made available to us. When the buyers left, we were able to photograph in the streets of Paris during the day. In the morning I would discuss the work from the night before with Gremela in my pidgin French (the office assistant used to kid me that I could go on for hours without using a verb). Paris was in turmoil then, loaded with international buyers. The taxi drivers who would come back each season to work with us had to make a mad dash back and forth, ferrying the clothes between the couturier houses and the studio in order to return them in time for the buyers to make their offers. The studio was like a boarding house; even taxi drivers took their meals there with us!

Mrs. Louise Dahl Wolfe
PHOTOGRAPHE
Adresse Hôtel San Regis à Paris

est autorisé à prendre des photos ou des modèles des collections parisiennes avant la date du : 29 Février 1956
pour le compte de: Harper's Bazaar (U.S.A.)

Le Délégué Général,

le 25. 1.56

CHAMBRE SYNDICALE
102 Faubourg St. Honoré
PARIS
DE LA COUTURE PARIS[?]

Ce Permis ne dispense pas son titulaire de demander l'autorisation formelle du Couturier-Créateur qui reste seul maître du droit de faire photographier ou dessiner ses modèles.

Each photographer had to have a pass to the showing of collections.

73

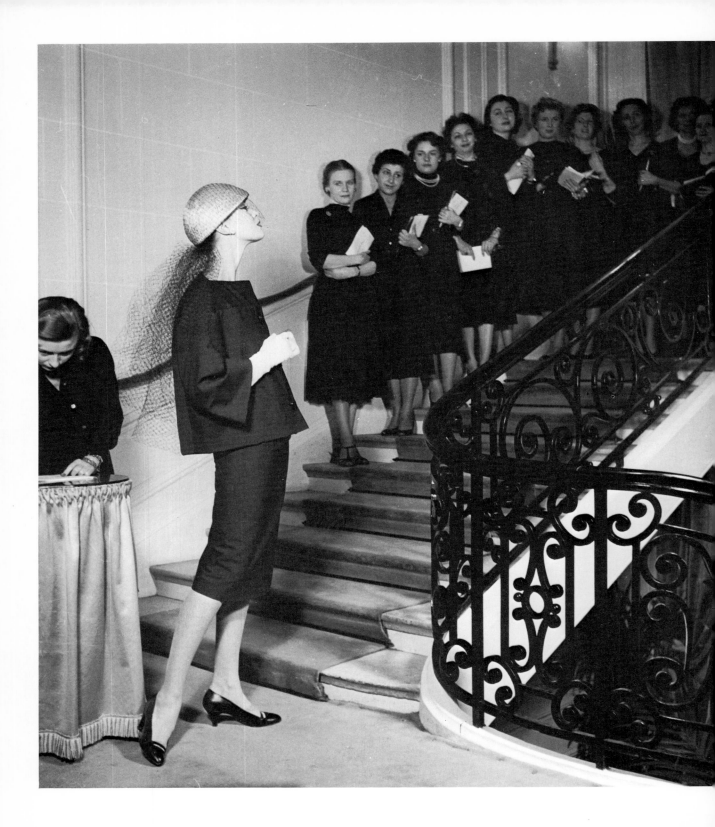

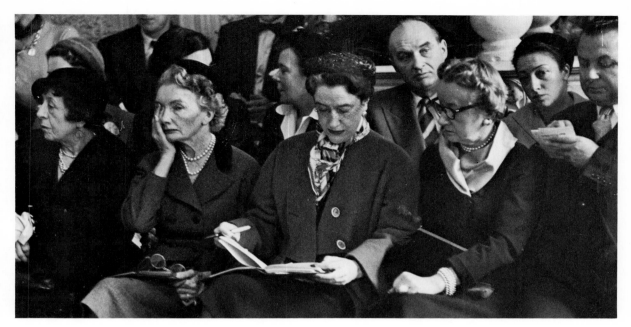

Exhausted from working the
collections; *left to right:*
Marie-Louise Bousquet, Paris
editor, *Bazaar*; Carmel; Bettina Wilson, *Vogue* fashion
editor; and Hattie Carnegie,
1947

*Opposite*
Opening day for trade buyers,
Dior's, 1946

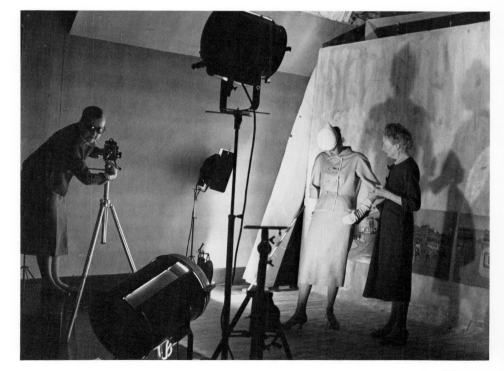

In the Paris studio, with
Carmel, late 1950s (photo:
Robert Doisneau)

**MODEL** near Quai d'Orsay is photographed by
Louise Dahl-Wolfe for a story in *Harper's Bazaar*.

News clip of Dior shoot; I am in a Dior suit, 1946

*Opposite*
This is the photo from the Louvre shoot, published in
*Harper's Bazaar*, November 1946.

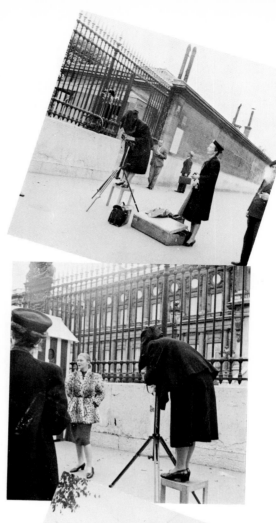

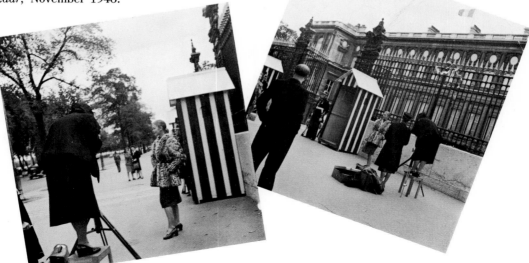

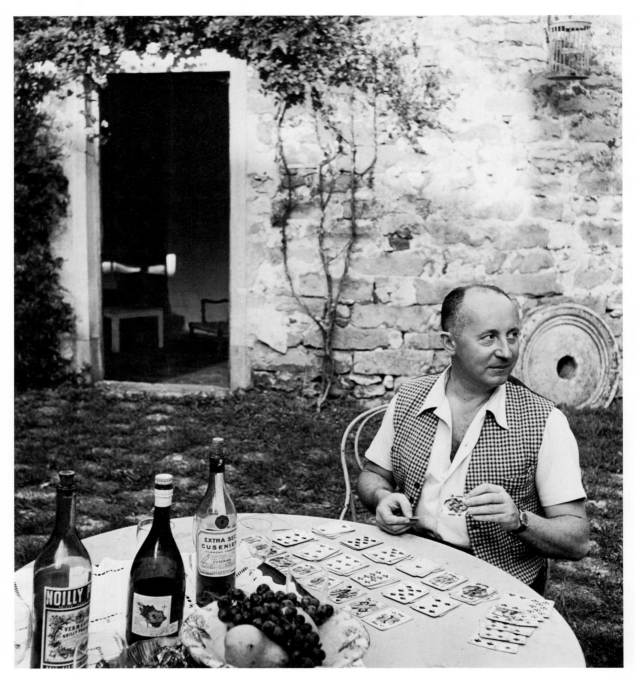

Christian Dior at his millhouse, outside Paris, 1946

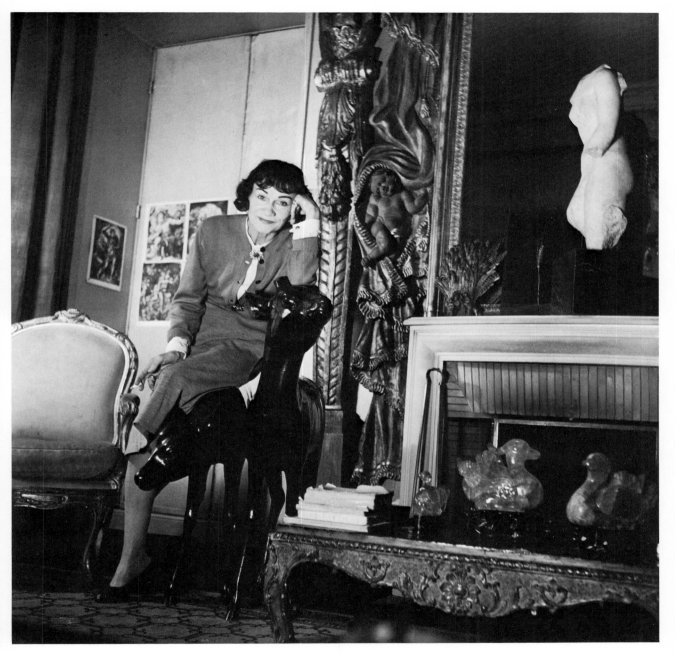

Coco Chanel, 1954

Cristobal Balenciaga, 1950

Jacques Fath and model Bettina, 1950

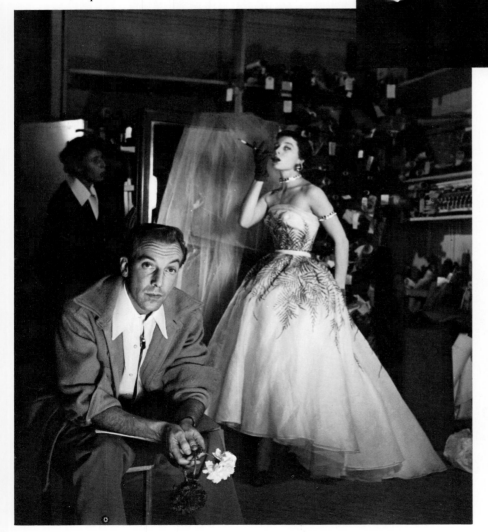

*Opposite*
Mizza Bricard, 1950s, co-designer with Dior at Lucien LeLong. When a fabric manufacturer started a new couturier house, he had to choose between them. He picked Dior, I think, because he was a man. Mizza was herself beautiful and much sought after. She criticized the standards of contemporary young women, telling me once how if she spent a night with a man, she would expect a jewel beneath her pillow the next day!

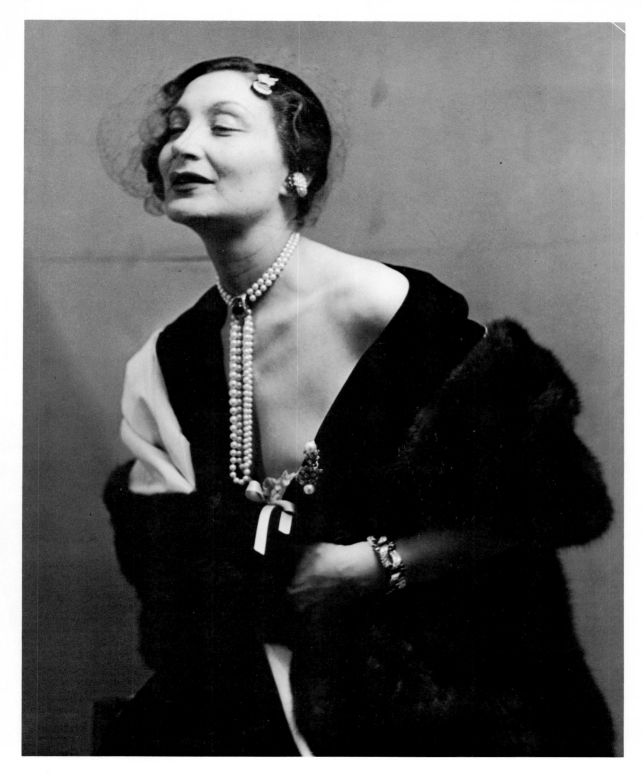

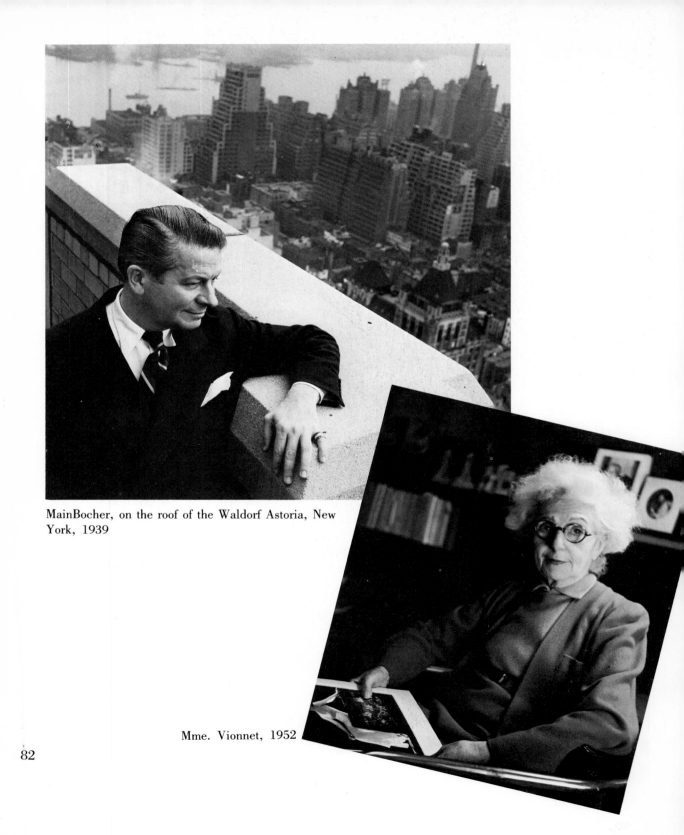

MainBocher, on the roof of the Waldorf Astoria, New York, 1939

Mme. Vionnet, 1952

82

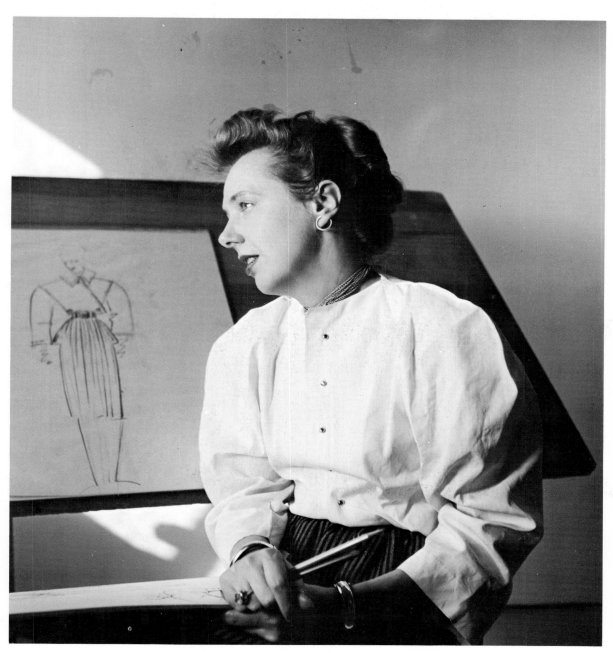

Claire McCardell, one of my favorite American designers

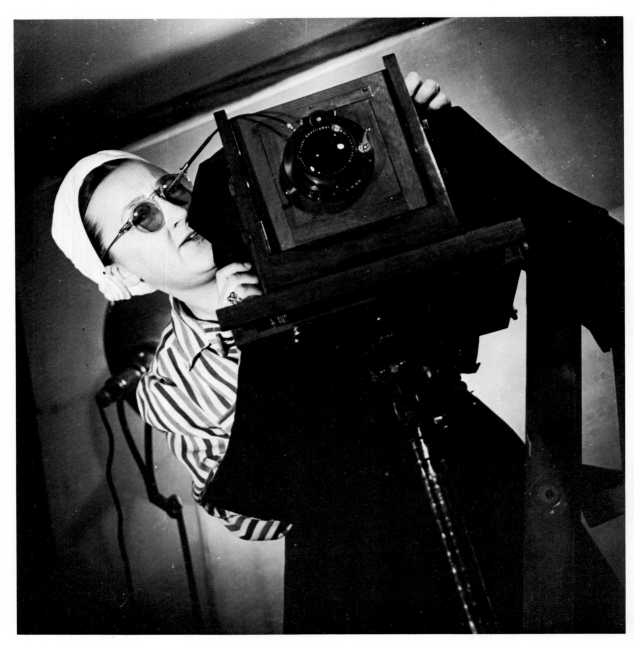

In my New York studio, 1938

# ON PHOTOGRAPHY

## STUDIO, LIGHTS, CAMERAS, COMPOSITION

I adored my studio in the Sherwood on 57th Street, an old red brick building built in 1860, with its large windows. The ceilings were fifteen feet high. This was a great asset for a boom overhead spotlight.

We worked hard, but we played hard too. Our English assistant, Harry Easton, was always ready to start a comedy, with the help of assistant Otto Fenn, using the studio props, accessories, etc. Alfred Linn kept our darkroom efficient and took charge of the lights during the sittings. I was the "Big Mama" with the help of Hazel Kingsbury, my right hand, who during the war deserted me for the Red Cross. Josephine Landl was our retoucher. Diana Vreeland, the *Bazaar*'s fashion chief, always called her "Madame Rembrandt."

I worked mostly with a Rolleiflex and a 3¼ × 4¼ Graflex, Cooke lens, which weighed seven pounds and hung around my neck. The result was three worn-down vertebrae, a trip to the hospital, and traction. After that, all my cameras, including Rolleis and Hasselblads, had to be on a tripod—doctor's orders. For color, I used only an 8 × 10 view camera with a twelve-inch Schneider lens.

On thinking over my long career in photography, particularly the twenty-two years that I was to spend at *Harper's Bazaar,* I believe that whatever successes I had were due to the knowledge I gained from the years spent at the San Francisco Institute of Art, and later on from the opportunity of working under an outstanding editor, Carmel Snow.

It is easy to learn, by yourself, the techniques of using the camera, darkroom printing,

85

Painting by Mike of me in my neck brace when I was in the hospital from carrying my Graflex, 1952

and developing of negatives. I learned photography in the early twenties without the exposure meter. You had to learn to judge the time to give the exposure by judging the degree or strength of the light. Edward Steichen, that great early photographer, thought he was the best "guesser" on exposures, but he had to confess, when the Weston exposure meter came on the market, that it was better at guessing than he was.

But if you want to learn the principles of design and composition for photography, going to an art school is the best answer. Drawing nudes in life class helped a great deal in fashion photography, making one conscious of the dif-

ferences between the male and female bodies in form and movement.

I believe that the camera is a medium of light, that one actually paints with light. In using the spotlights with reflecting lights, I could control the quality of the forms revealed to build a composition. Photography, to my mind, is not a fine art. It is splendid for recording a period in time, but it has definite limitations, and the photographer certainly hasn't the freedom of the painter. One can work with taste and emotion and create an exciting arrangement of significant form, a meaningful photograph, but a painter has the advantage of putting something in the picture

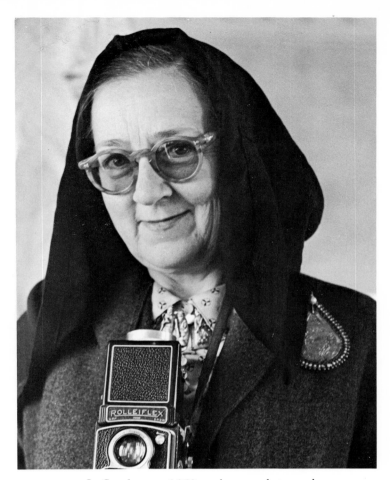

In Sweden, c. 1950, unknown photographer

that isn't there or taking something out that is there. I think this makes painting a more creative medium.

In the years 1958–1960 I had the pleasure of working for *Sports Illustrated*, too. I did some food shots for them and a series on male gourmet cooks.

87

At my New York studio, 1953. Everyone—assistants, retoucher, Mike—helps to create backgrounds.

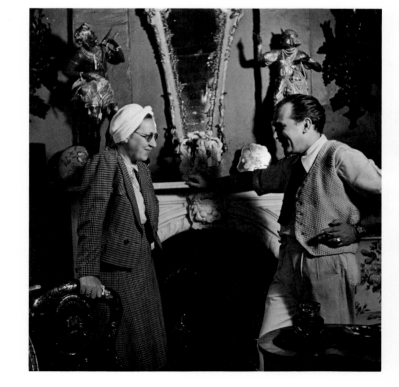

At "The Flea Market" with Elmo Avet, proprietor, in the early 1940s. He always had some marvelous treasure for me to use in my backgrounds.

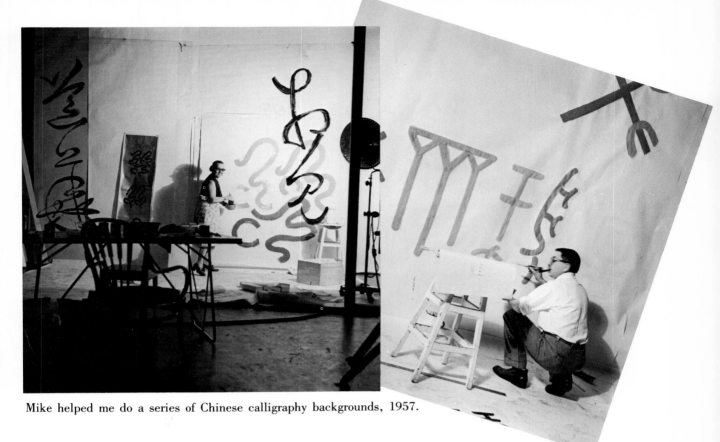

Mike helped me do a series of Chinese calligraphy backgrounds, 1957.

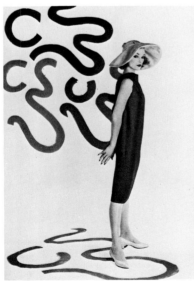

Here's the photo using Mike's calligraphy background, as it appeared in *Harper's Bazaar*, April 1958

I HAD STUDIED WITH A Chinese PROFESSOR AND WAS MOST Delighted when I learned how to do my own name in Chinese, THE BAZAAR gave me four pages to do in color. IT WAS Spring AND SUDDENLY I Thought of CALigRAphy, SO I looked over THE CHARACTERS THAT I KNEW AND chose THE ones that worked THE best in THE given spaces. One CHARACTER TURNED out to mean "WORMS" but I couldn't Resist using the fascinating Twists AND Curves, so I USED IT AND IRIS THE MODEL SEEMED perfectly TRANQUIL DURING THE SITTING, AMID THE WORMS.

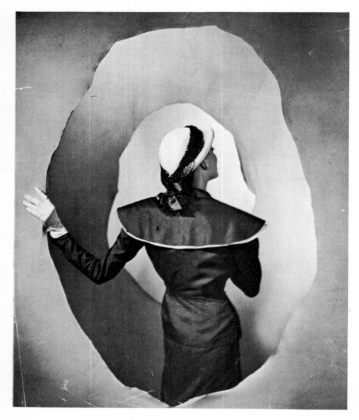

Inspired by Matisse, Mike and I took scissors and paper to create backgrounds. The model is Betty Threat, 1947.

*"Independent, awash in ideas, and irrepressibly humorous, Dahl-Wolfe rarely let veneration for a celebrity or the canons of behavior or high style dictate her approach. She bypassed the taffeta drama and woolly dignity that held the Bazaar together, slipping a trace of puckish humor into the fashion pages. Her mind stocked with images from the history of art, she made dry comments about fashion and fashion photography as art by pairing clothes with museum pieces. Once she*

*posed a slim model in a nightgown in front of a blow-up of one of Toulouse-Lautrec's blowsy whores in her nighty. She loved lingerie assignments, and would arrange her models in peignoirs next to the uncorseted nudes of Rubens and Veronese. In her Matisse period the backgrounds were abstract color cutouts; sometimes the models held scissors as if they had just produced their settings.*

*She stole through the history of art and illumination with a pickpocket's hand and a racing wit; she borrowed all over the place. Both Huene and Man Ray had used oversized graphics once or twice before Dahl-Wolfe did, but she made this element of strong design so integral a part of her fashion work that it became a kind of signature."*
—*Vicki Goldberg*

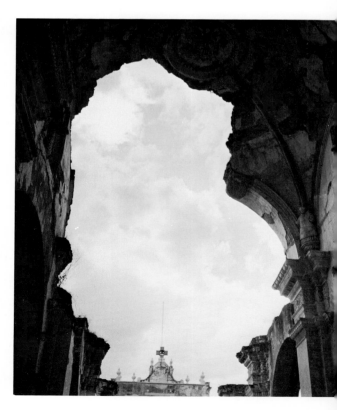

Recollection Cathedral, Antigua, 1952. I was always fascinated by "holes," and have a series taken around the world.

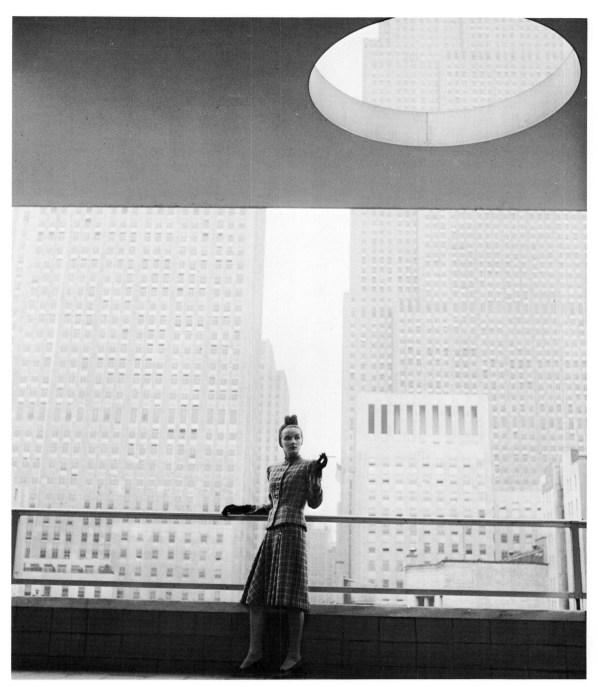

91

Balcony of Museum of Modern Art, 1940

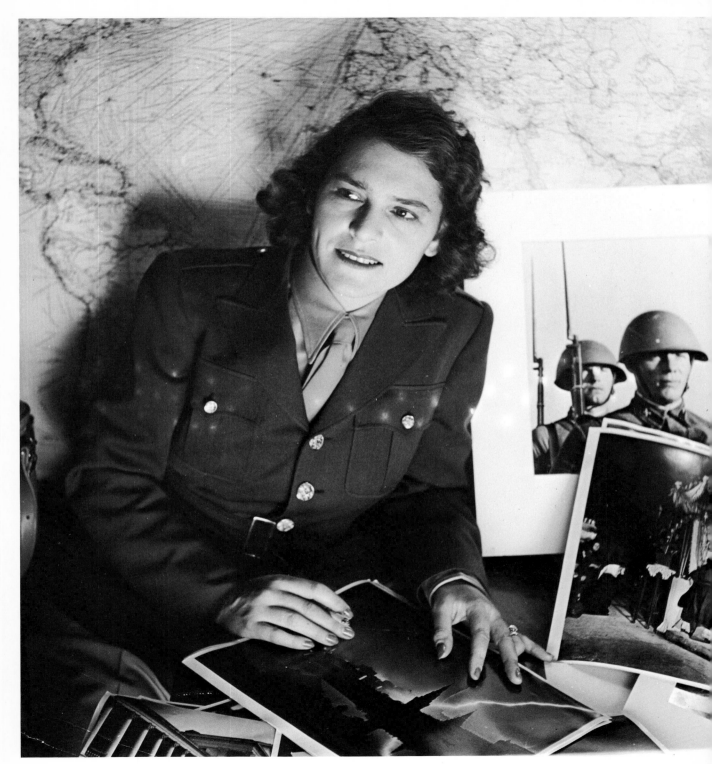

Margaret Bourke-White, 1942

Cecil Beaton, 1950

John Rawlings of *Vogue* with Louise at the "Party of the Year" at the Plaza, held by the Seventh Avenue manufacturers, 1940s

Horst with Louise, 1940s

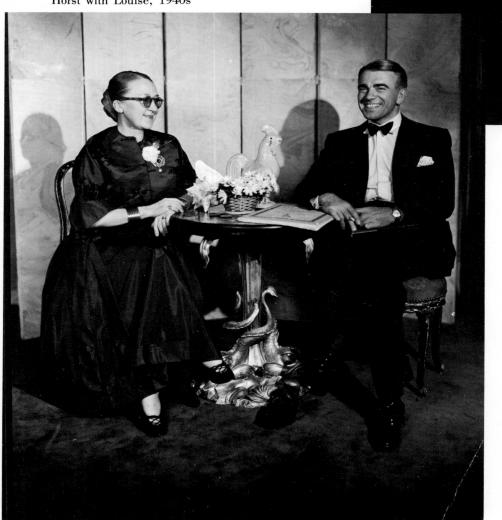

Brassaï making French salad at my house, The Creamery, New Jersey. I admired this photographer. Some of my other favorites were Cartier-Bresson, the Paris work of Hoyningen-Huene, the dramatic lighting of Horst, and Steichen whose portraits I followed for years.

George Hoyningen-Huene, Hans Jorgenson (my assistant), me, and Carmel Snow, at a party in honor of my assistants going off to war

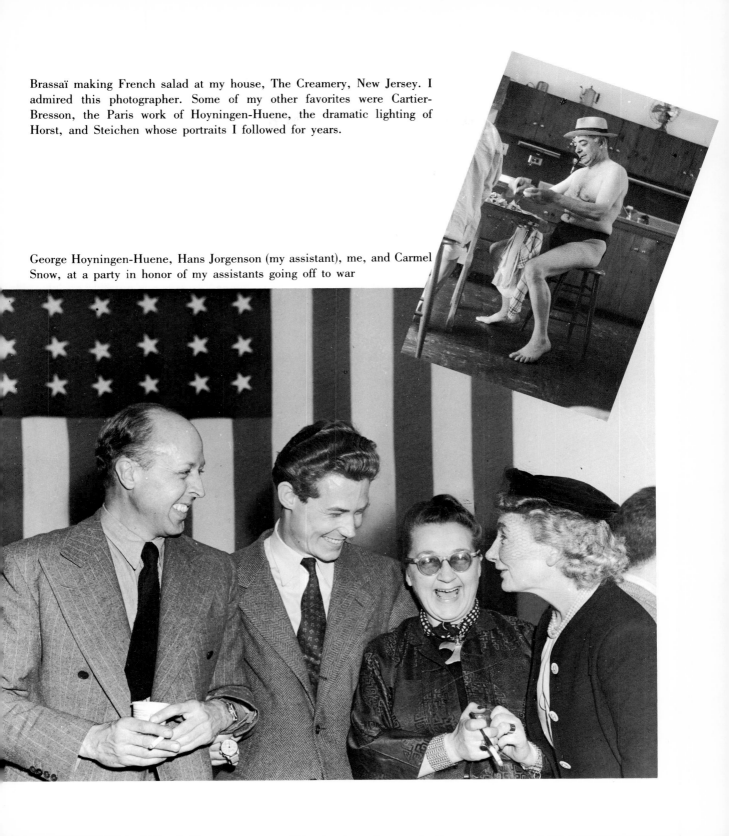

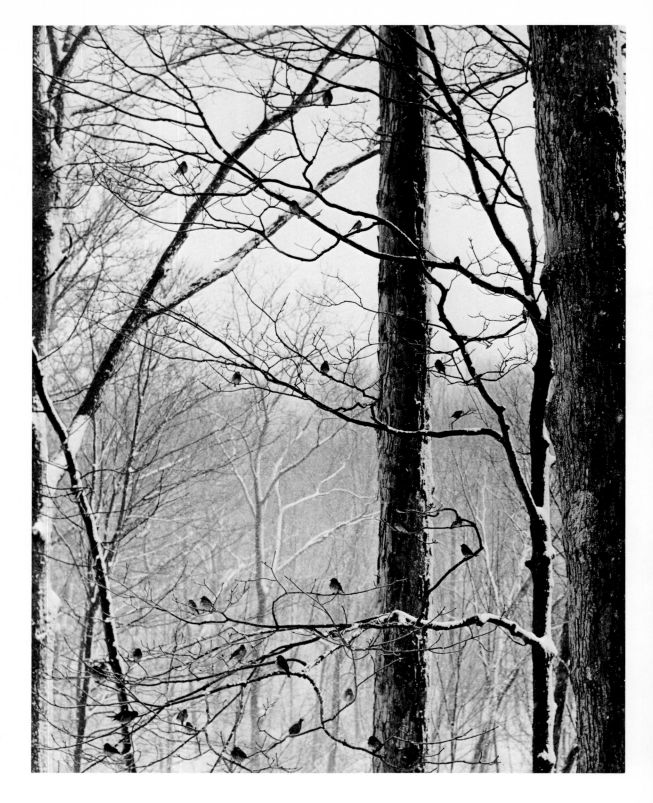

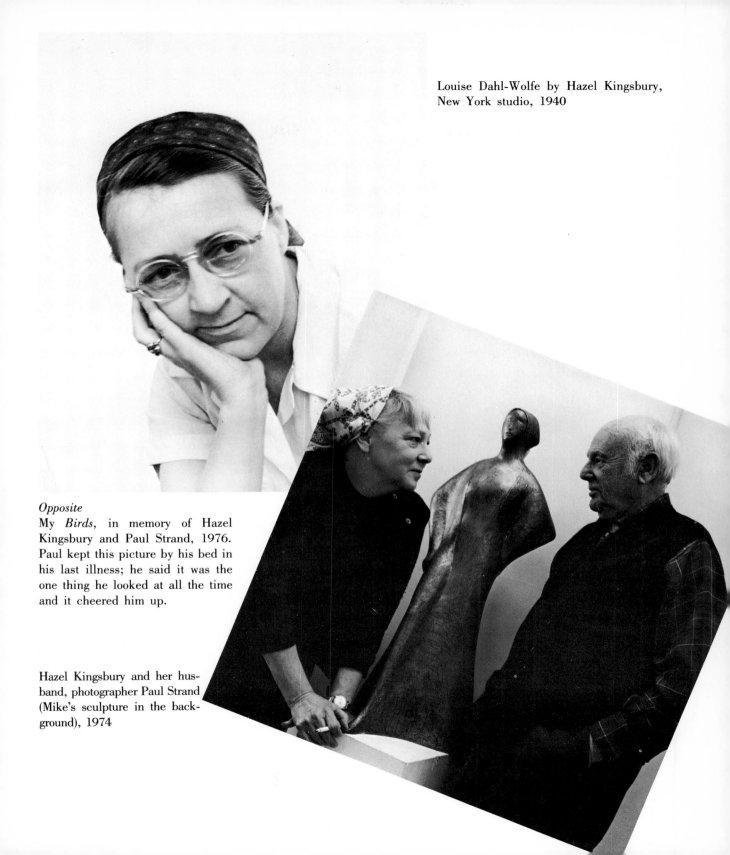

Louise Dahl-Wolfe by Hazel Kingsbury, New York studio, 1940

*Opposite*
My *Birds*, in memory of Hazel Kingsbury and Paul Strand, 1976. Paul kept this picture by his bed in his last illness; he said it was the one thing he looked at all the time and it cheered him up.

Hazel Kingsbury and her husband, photographer Paul Strand (Mike's sculpture in the background), 1974

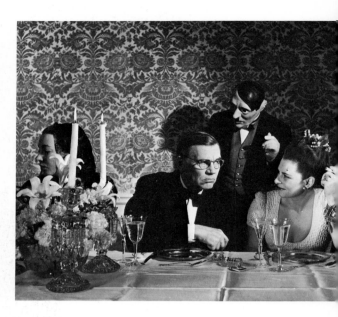

*Walls Have Ears* series made for the government war effort, 1942

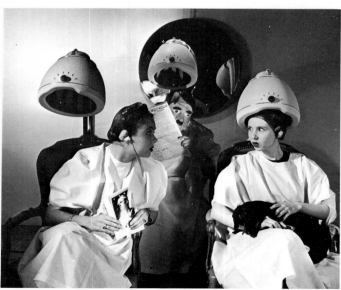

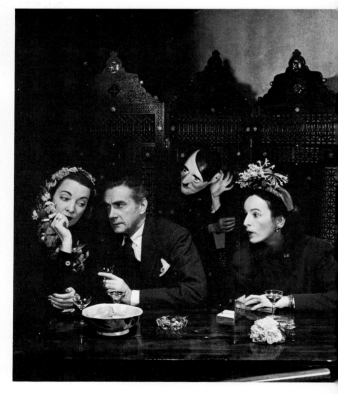

# WAR YEARS

Letter, *Walls Have Ears*, from Director, National Plan to Guard Against the Danger of "Careless Talk"

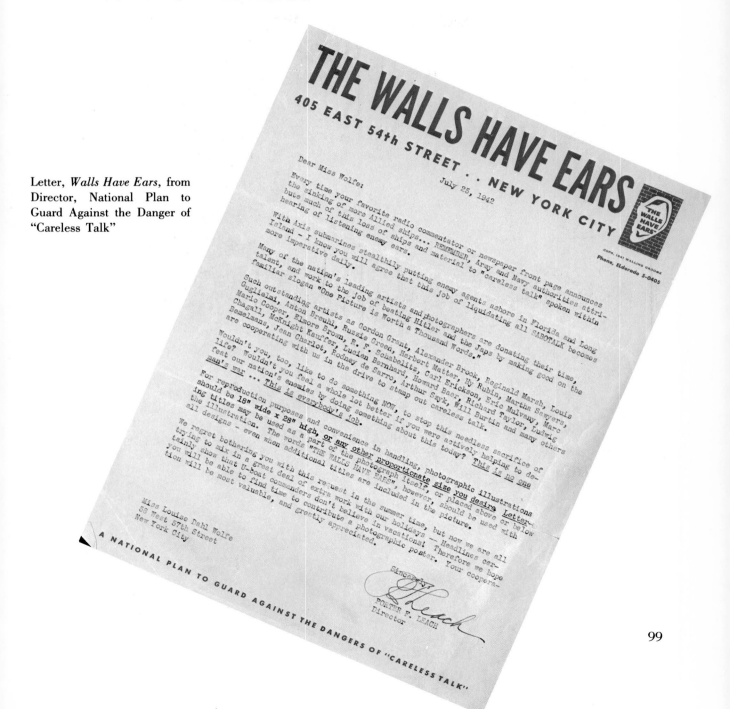

# THE WALLS HAVE EARS
## 405 EAST 54th STREET .. NEW YORK CITY

July 25, 1942

Dear Miss Wolfe:

Every time your favorite radio commentator or newspaper front page announces the sinking of more Allied ships... REMEMBER, Army and Navy authorities attribute much of this loss of ships and material to "careless talk" spoken within hearing of listening enemy ears.

With Axis submarines stealthily putting enemy agents ashore in Florida and Long Island – I know you will agree that this job of liquidating all SABOTALK becomes more imperative daily.

Many of the nation's leading artists and photographers are donating their time, talent, and work to the job of beating Hitler and the Japs by making good on the familiar slogan "One Picture is Worth a Thousand Words."

Such outstanding artists as Gordon Grant, Alexander Brook, Reginald Marsh, Louis Guglielmi, Anton Bruehl, Ruzzie Green, Herbert Matter, Hy Rubin, Martha Sawyers, Mario Cooper, Elmore Brown, R. F. Schabelitz, Carl Erickson, Eric Mulvany, Marc Chagall, McKnight Kauffer, Lucien Bernhard, Howard Baer, Richard Taylor, Ludwig Bemelmans, Jean Charlot, Rodney de Sarro, Arthur Szyk, Will Burtin and many others are cooperating with us in the drive to stamp out careless talk.

Wouldn't you, too, like to do something NOW, to stop this needless sacrifice of life? Wouldn't you feel a whole lot better if you were actively helping to defeat our nation's enemies by doing something about this today? This is no one man's war ... This is everybody's job.

For reproduction purposes and convenience in handling, photographic illustrations should be 18" wide x 28" high, or any other proportionate size you desire Lettering titles may be used as a part of the photograph itself, or placed above or below the illustration. The words "THE WALLS HAVE EARS", however, should be used with all designs – even when additional titles are included in the picture.

We regret bothering you with this request in the summer time, but now we are all trying to mix in a great deal of extra work with our holidays — Headlines certainly show that U-boat commanders don't believe in vacations! Therefore we hope you will be able to find time to contribute a photographic poster. Your cooperation will be most valuable, and greatly appreciated.

Sincerely,

PORTER F. LEACH
Director

Miss Louise Dahl Wolfe
56 West 57th Street
New York City

### A NATIONAL PLAN TO GUARD AGAINST THE DANGERS OF "CARELESS TALK"

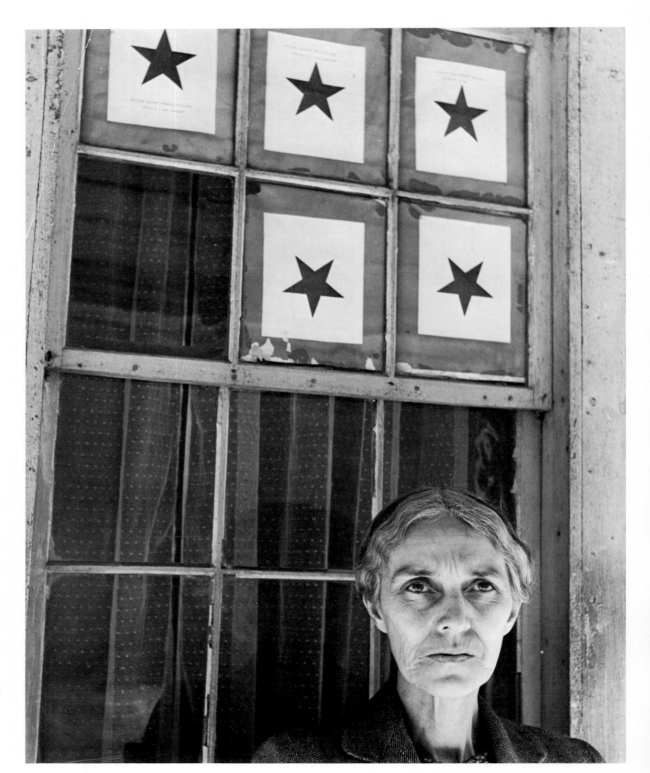

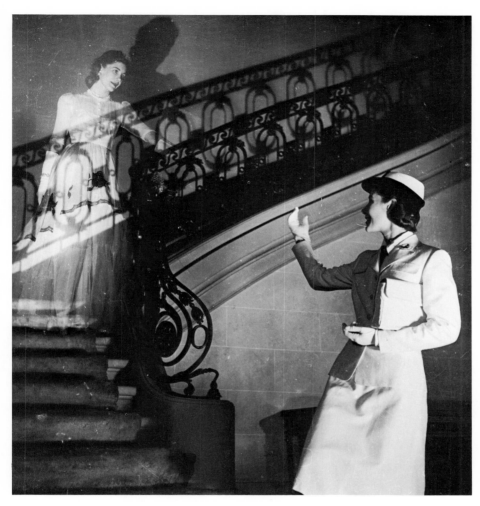

*Goodbye to all that*, Louise Macy in Wave uniform, July 1943

*Five Star Mother*, Nashville, c. 1943. Each star is for a son gone to the war.

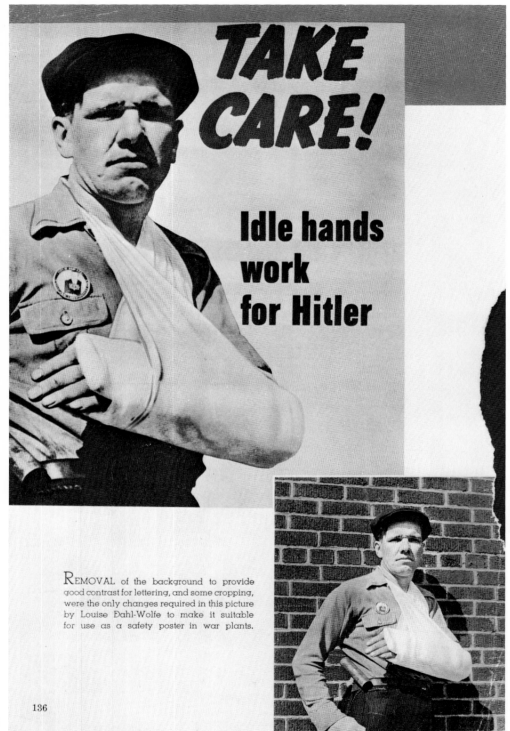

REMOVAL of the background to provide good contrast for lettering, and some cropping, were the only changes required in this picture by Louise Dahl-Wolfe to make it suitable for use as a safety poster in war plants.

136

Poster of prize-winning portrait of Danish seaman, 1942

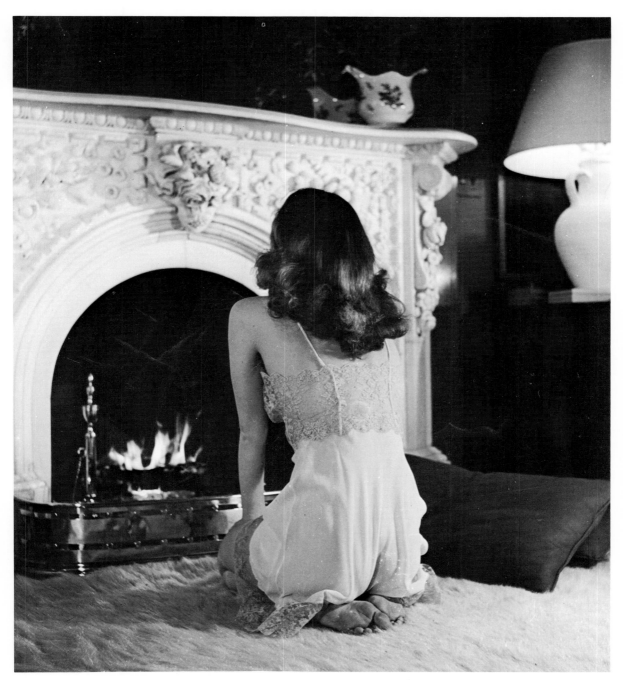

*Keep the Home Fires Burning*, June Vincent, 1942

Our twenty-fifth anniversary, posing in our clothes from 1928, when we met

104

# MIKE AND ME

Mike was of great help in my photographic career. He was good to lean on and very helpful when business problems came along, and generous in painting backgrounds when I needed something different, even when he was deep into his own work of drawing, making lithographs, doing sculpture or painting. Often I had difficult sittings, and would become excited. Mike was one of the few who could soothe the situation, bringing order to it. He nicknamed me "Queen Louise," and with his marvelous sense of humor could bring me down off my royal horse. There's no one like Mike! I love his philosophic understanding and outlook on life. We've had a wonderful life together and I'm grateful that I was so lucky. It's now 56 years!

Mike and me in Norway, c. 1950

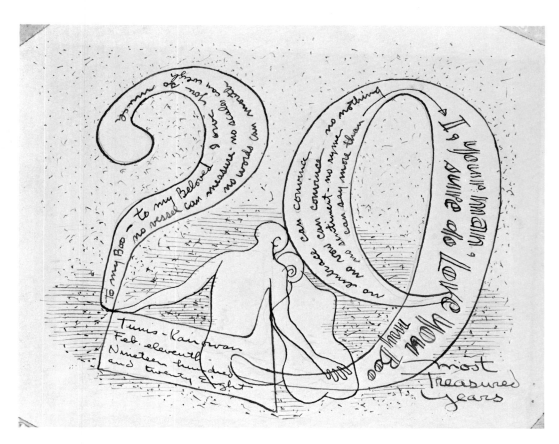

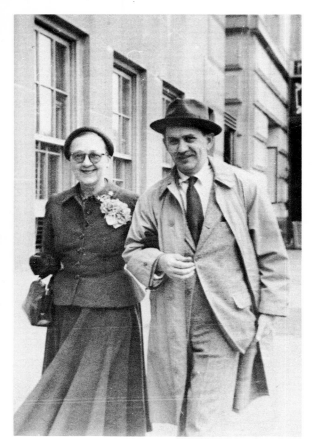

In my Dior "New Look" suit, New York, 1947. This is one of my favorite pictures of us, taken by a street photographer.

*Opposite*
Our twenty-ninth anniversary. People ask why I chose a hyphenated name. There was another photographer named Wolfe, very commercial, with whom I didn't want to be confused, so I kept my name but added Mike's because I loved him.

Mike's drawing for me, our twenty-third anniversary, 1951

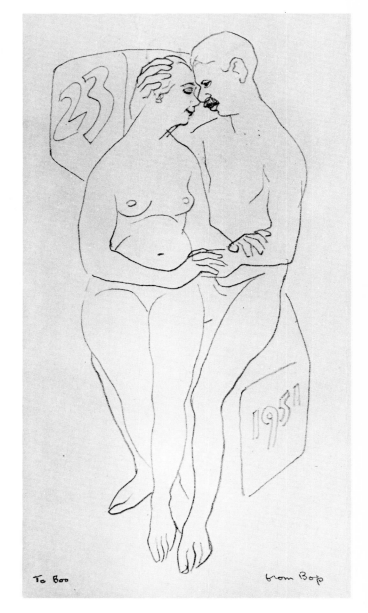

Shooting Ingrid Bergman, on the Hudson, c. 1939

108

# PORTRAITS

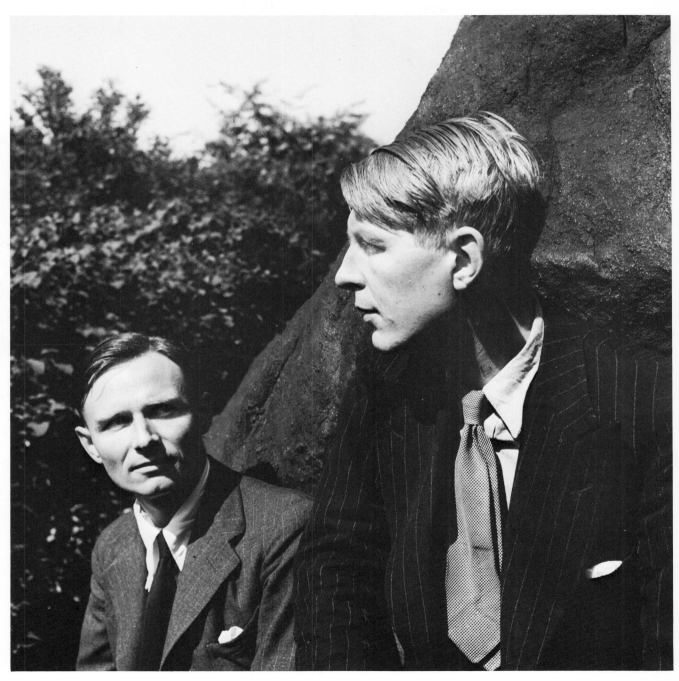

Christopher Isherwood and W. H. Auden, Central Park, 1938

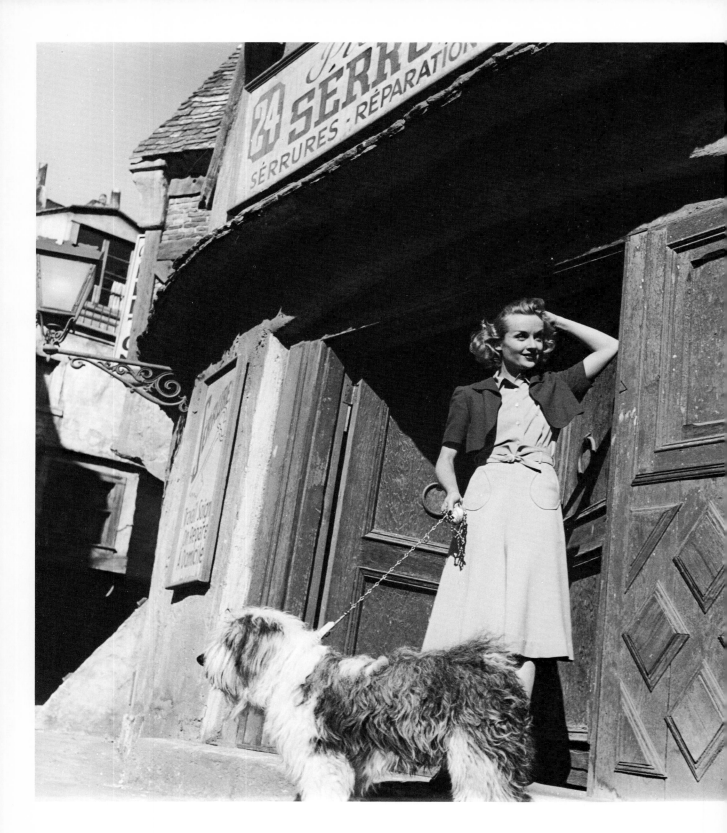

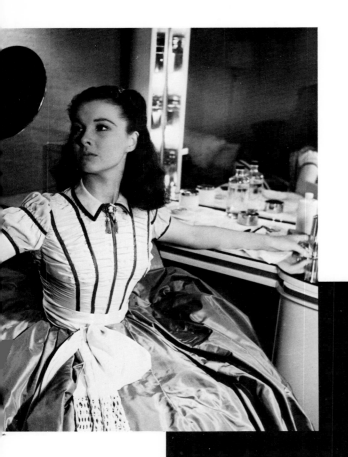

Vivien Leigh, 1938, dressing room, *Gone with the Wind*

Marlene Dietrich in *Destry Rides Again*, 1938

Carole Lombard,
Hollywood, "on the
lot," 1938

Paul Muni, 1939

Orson Welles, 1938

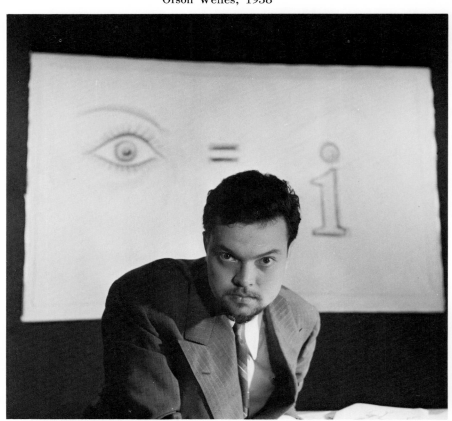

112

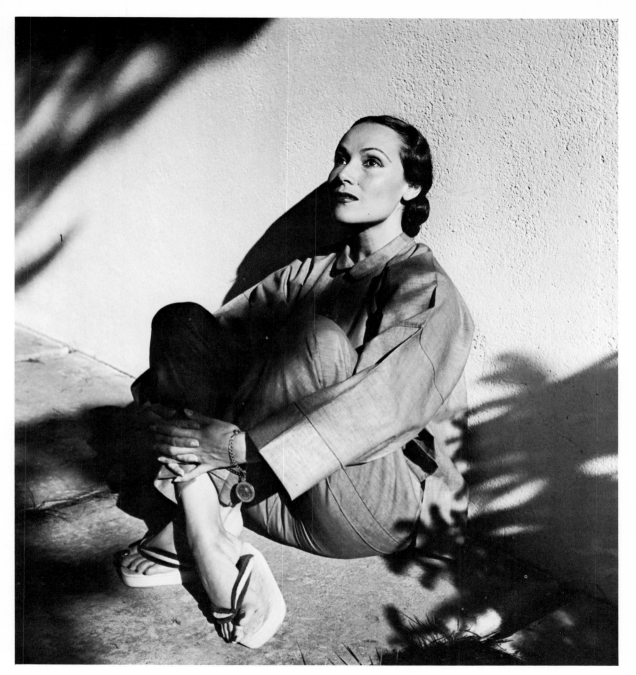

Dolores del Rio, Hollywood, 1938. Ten years later I visited her in Mexico to shoot another portrait for *Harper's Bazaar*. I had her stand in front of a clean whitewashed wall, but since these were the servants' quarters, she refused. I hid my outrage and allowed her to pose where she chose, admonishing my assistant not to load the camera, and proceeded to fake a roll of film. We never got a picture from that session!

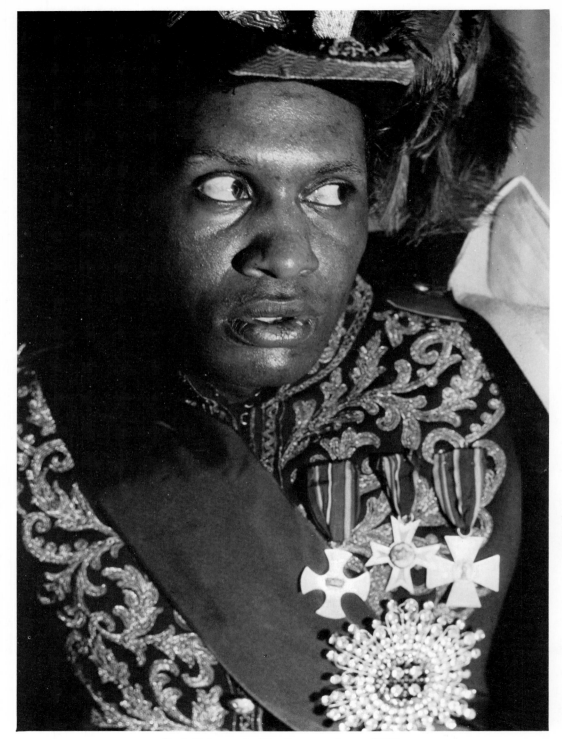

114

Paul Robeson in *The Emperor Jones*, 1933

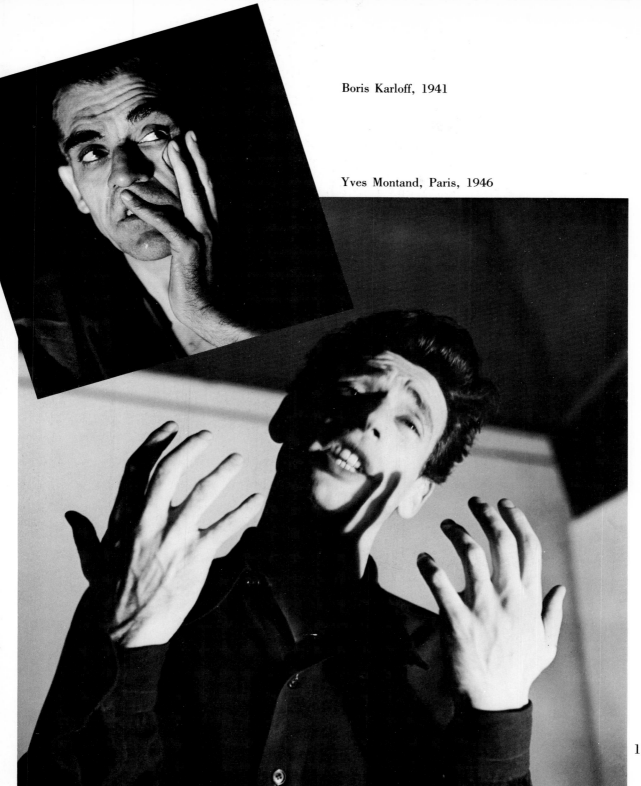

Boris Karloff, 1941

Yves Montand, Paris, 1946

115

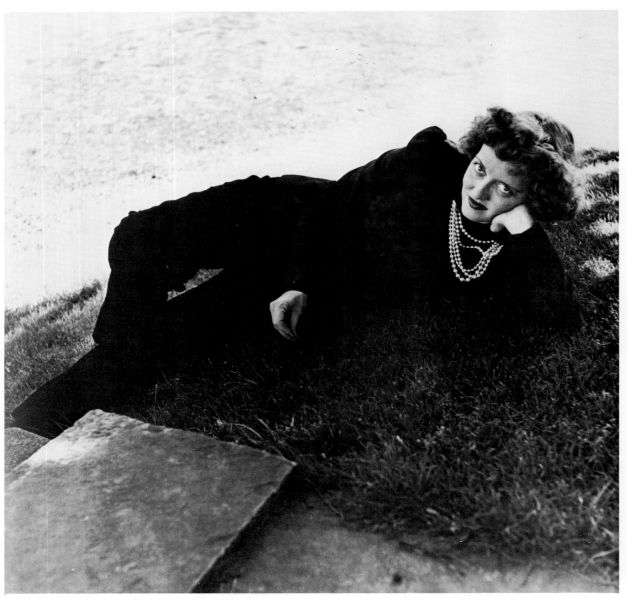

Bette Davis, Hollywood, 1938. She was a perfectionist, never allowing the hairdressers to overdo her hair. She had excellent taste and knew what was best for her appearance.

Paulette Goddard, Hollywood, 1940

Gypsy Rose Lee in her New York apartment, 1942

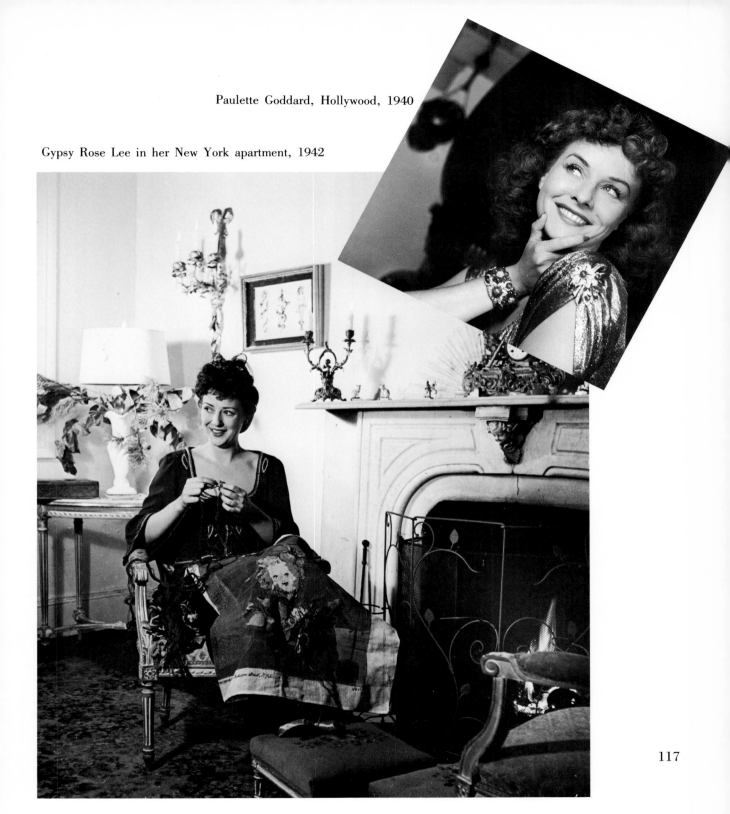

117

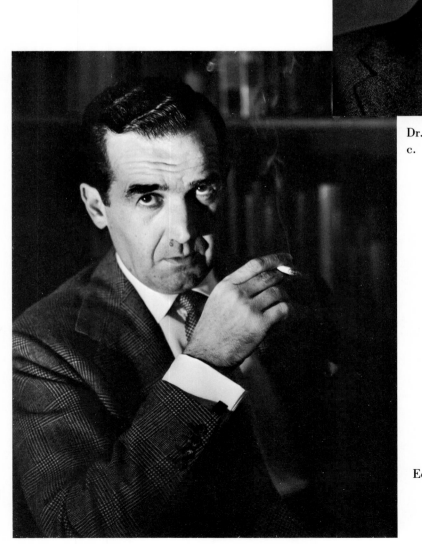

Dr. Ernest Jones, biographer of Freud, c. 1958

Edward R. Murrow, 1953

118

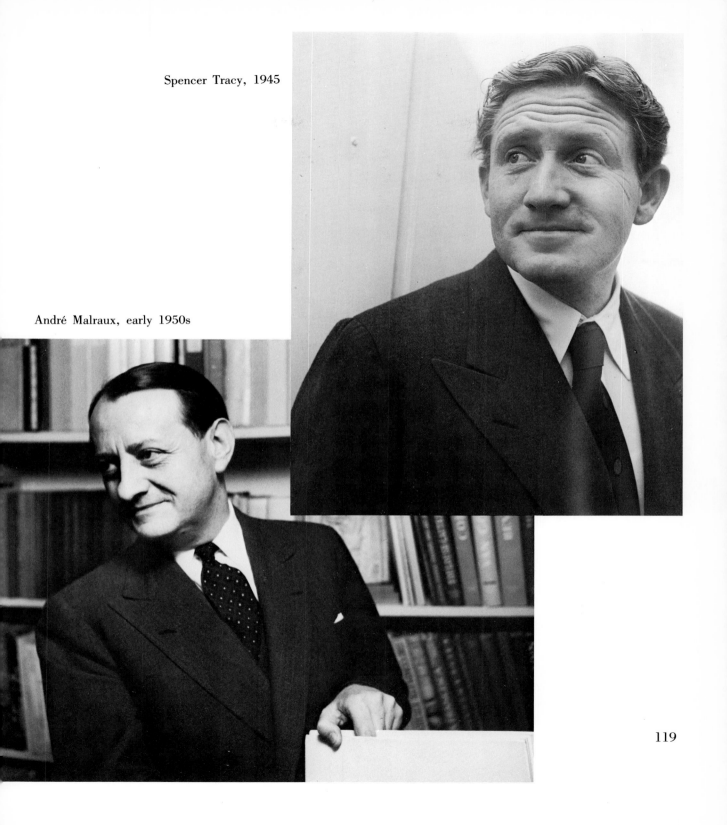

Spencer Tracy, 1945

André Malraux, early 1950s

119

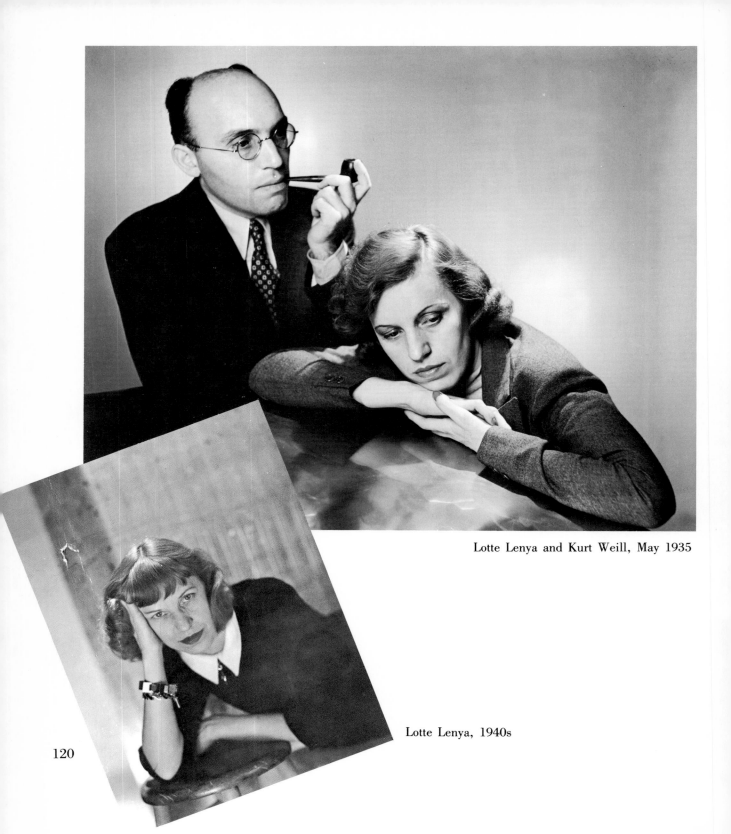

Lotte Lenya and Kurt Weill, May 1935

Lotte Lenya, 1940s

120

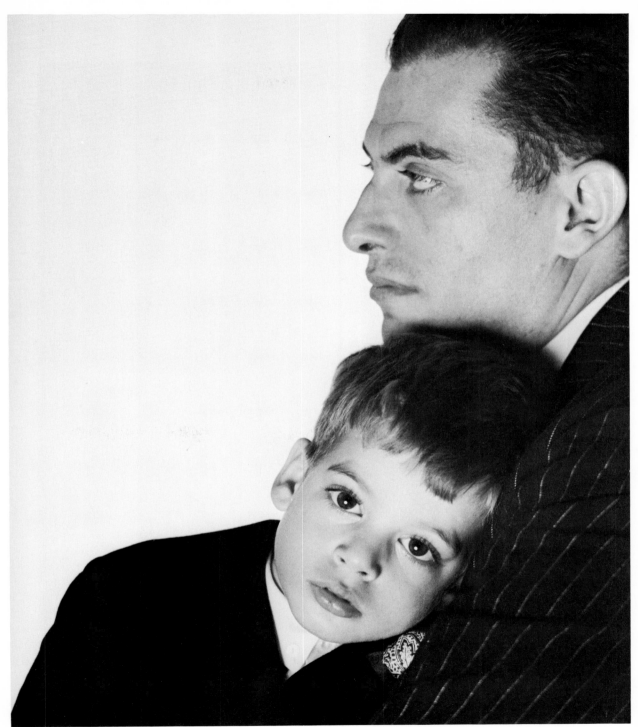

121

Ben Schultz and son Alexander, 1960

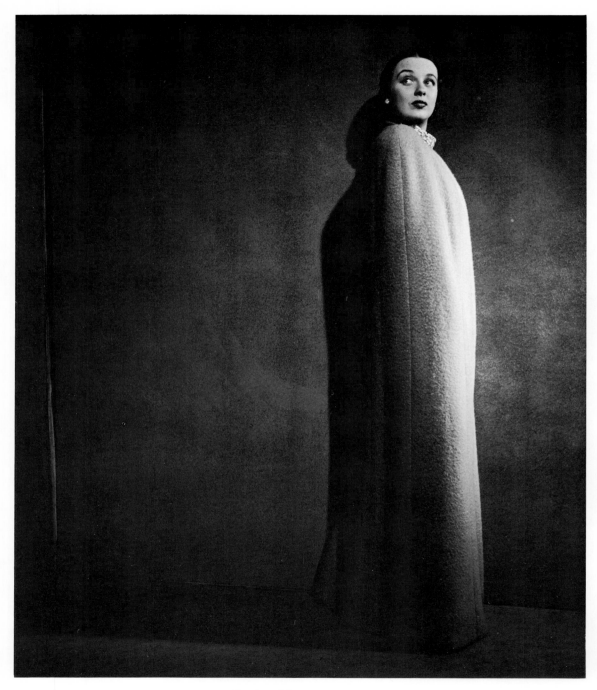

122

Patricia Morrison, 1940

Greer Garson, c. 1942

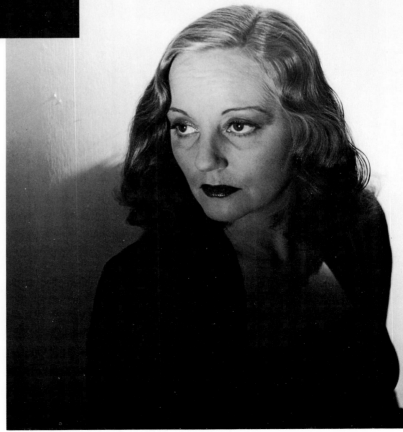

Talullah Bankhead, 1942

123

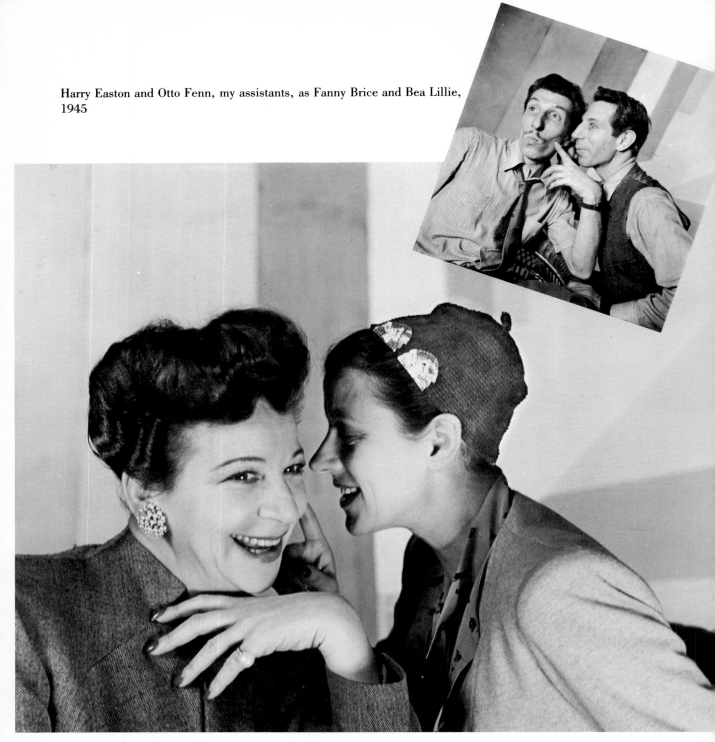

Harry Easton and Otto Fenn, my assistants, as Fanny Brice and Bea Lillie,
1945

Fanny Brice and Bea Lillie, 1945

Mae West, Hollywood, 1944

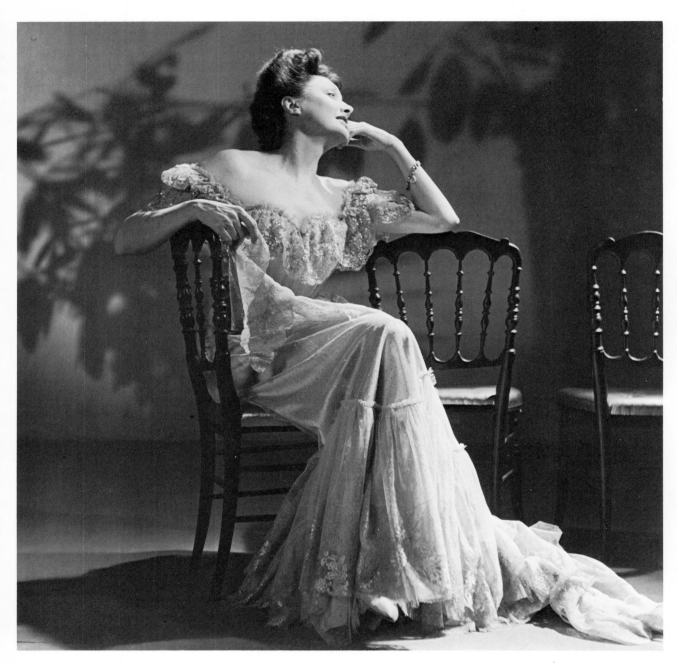

Katharine Cornell in *The Doctor's Dilemma*, 1950

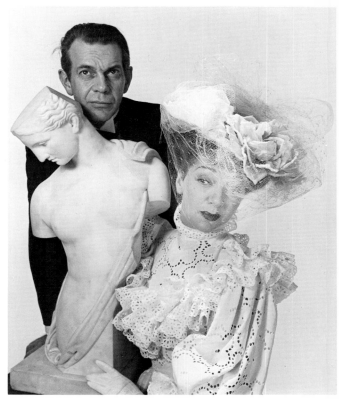

Raymond Massey and Gertrude Lawrence in
*Pygmalion*, 1945

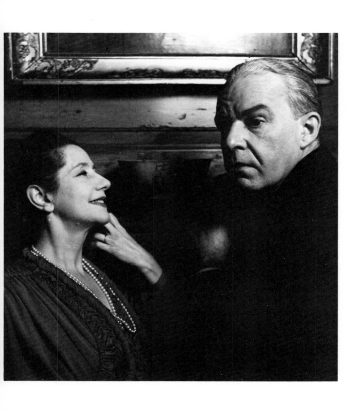

Alfred Lunt and Lynn Fontanne, 1946

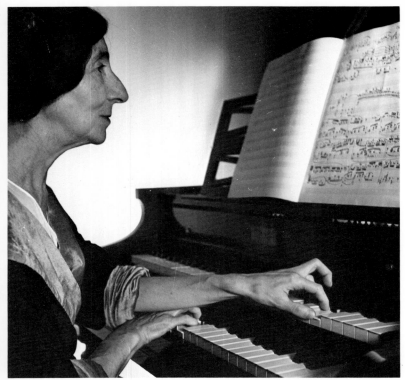

Wanda Landowska, New York, 1945. I was
surprised at how small she was. Proud of her
long, heavy hair, she insisted on wearing it
down, making her look, I thought, like a
dwarf. After a bit, I persuaded her to put it
up for this picture.

*Opposite*
Edith Sitwell, New York, 1951

Elsie de Wolfe (Lady Mendl), Paris, 1946

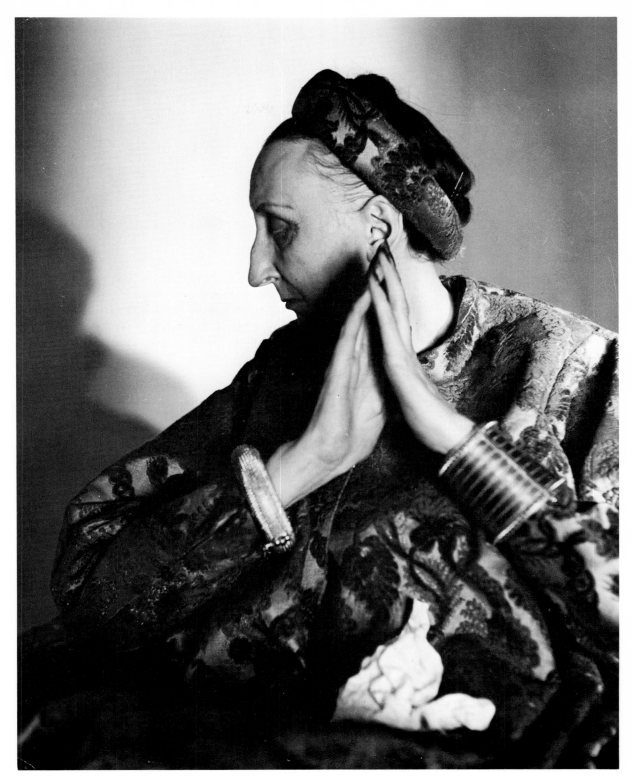

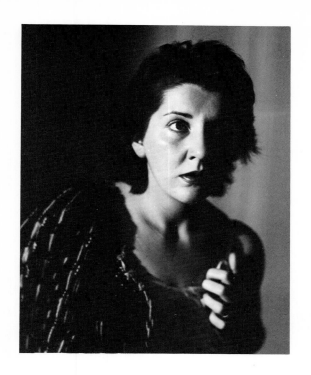

Maureen Stapleton in *The Rose Tattoo*, New York, 1951

*Opposite*
Hume Cronyn and Jessica Tandy, New York, 1949

Celebrating *Call Me Madam*, New York, 1950; *left to right:* Howard Lindsay, Russell Crouse, Ethel Merman, Irving Berlin. I felt there was something missing in this composition and had Mike extend his tuxedoed arm, extreme bottom right.

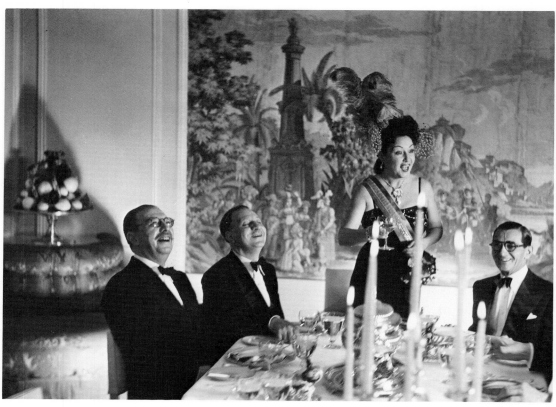

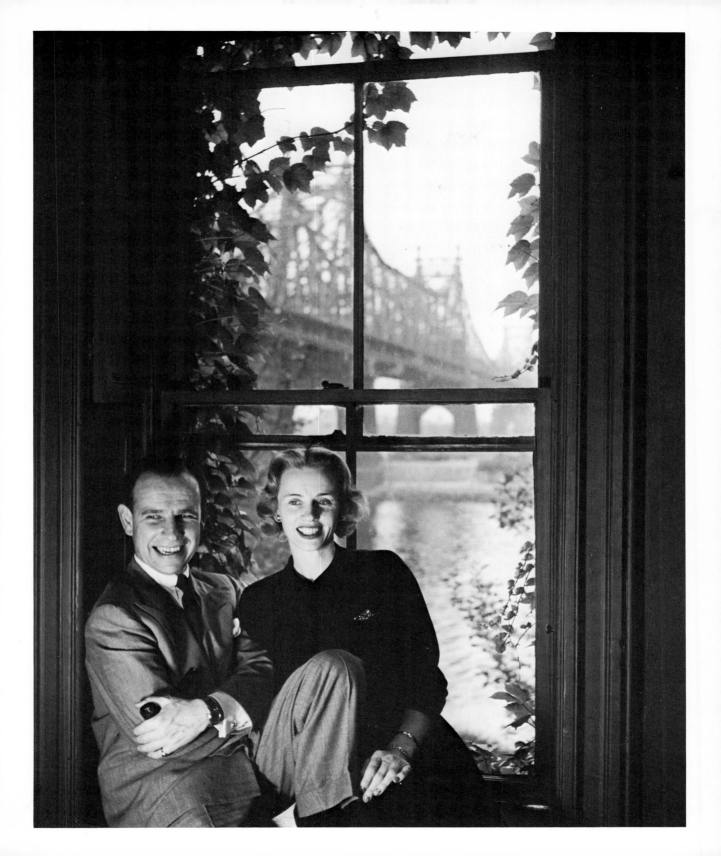

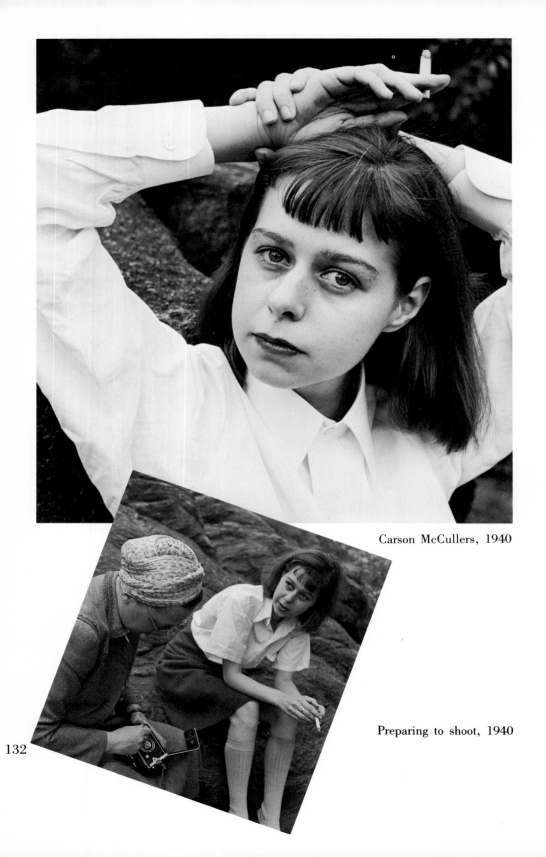

Carson McCullers, 1940

Preparing to shoot, 1940

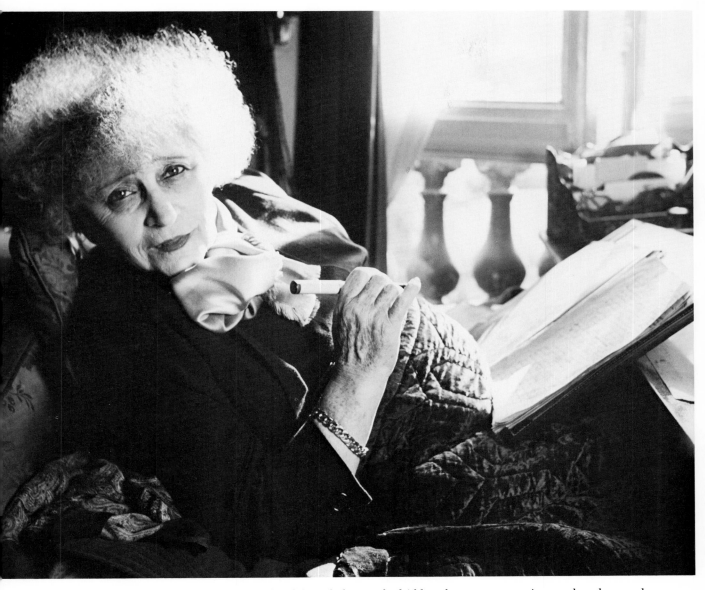

Colette, Paris, 1951. It was the last year of her life and she was bedridden, but so very gracious and such a good sport that I worked fast in order not to tire her too much.

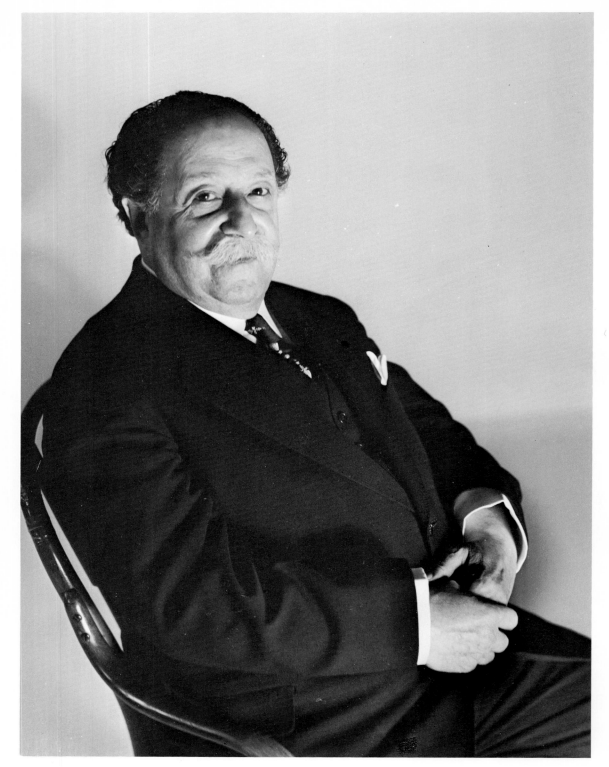

134

Pierre Monteux, 1954. This is one of my favorite portraits; it still talks to me, with those sparkling, happy eyes.

Triptych of Jimmy Durante, 1945

135

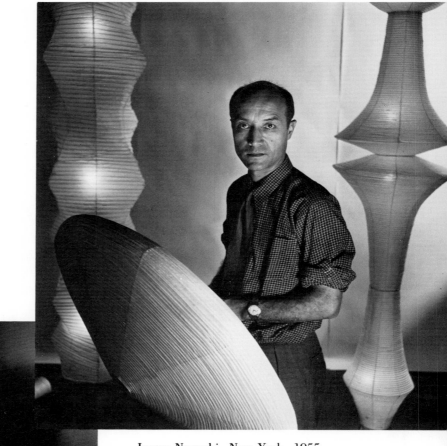

Isamu Noguchi, New York, 1955

Kenneth Tynan, 1954

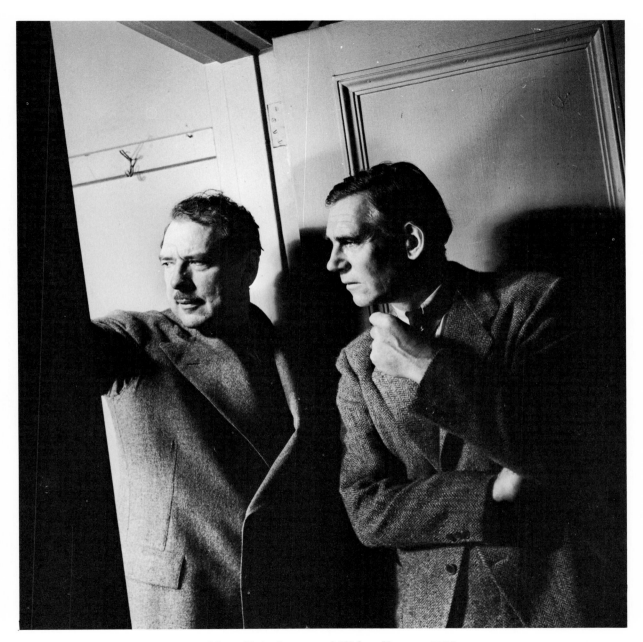

Maxwell Anderson and Walter Huston, 1938

138                              Eudora Welty, early 1950s

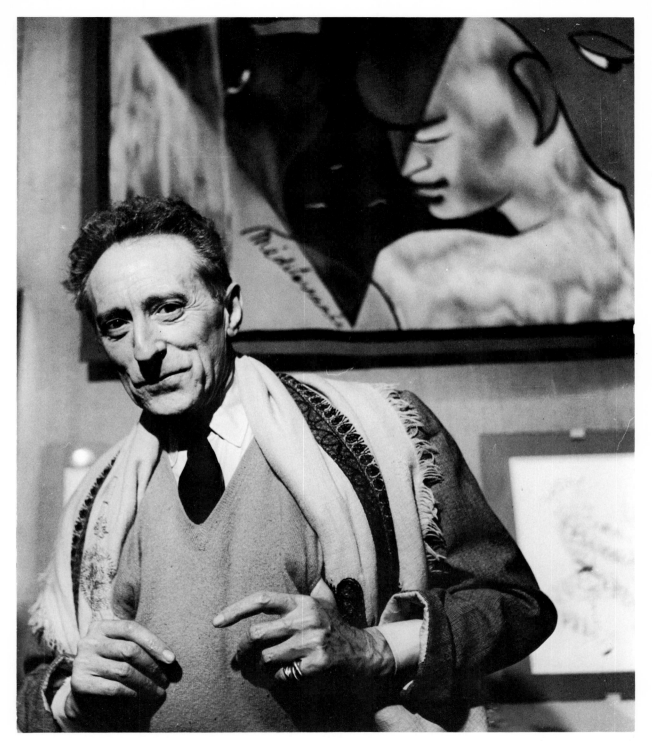

Jean Cocteau, Paris 1955

140

Sigrid Undset, Nobel Prize winner for literature, New York, 1940

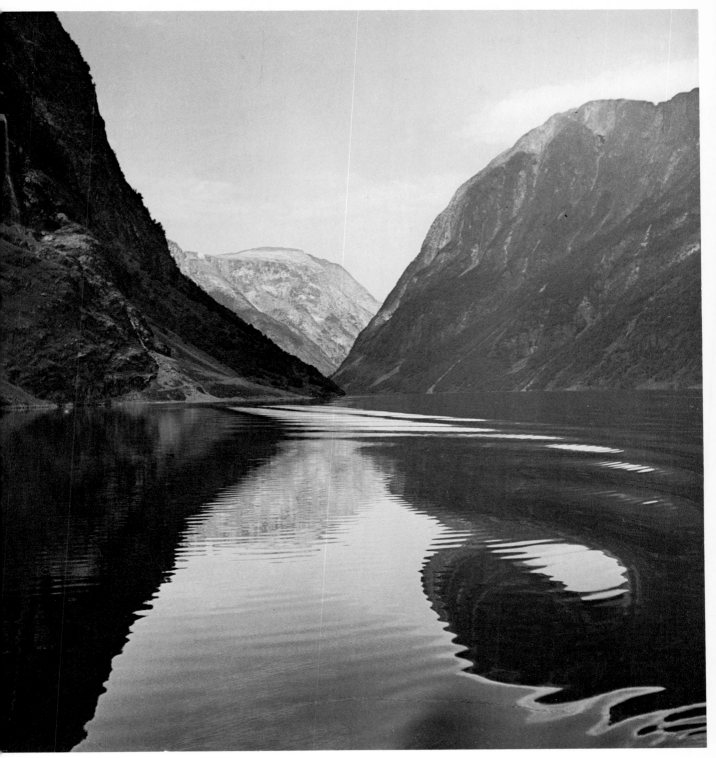

Sögne Fjord, Norway, 1950

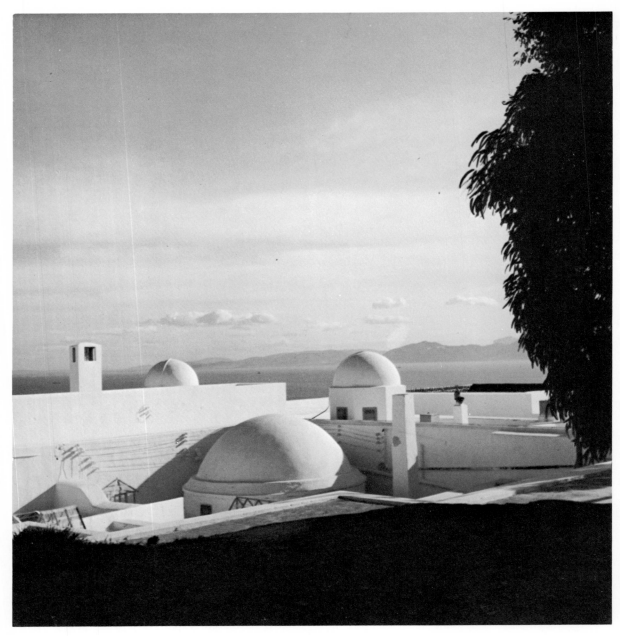

Return to Kairouan, 1950

# PHOTOGRAPHY TODAY

When my fashion photographs, nudes, portraits, and pictorials were being shown at New York University's Grey Gallery and the Staley-Wise Gallery in New York, there were many charming and enthusiastic people who came to see them. I found it interesting to talk to the young working in photography today and to hear their views. I was about to leave when I met a young lady who told me about her current career as a fashion photographer. I was overwhelmed with concern by her story.

I realized as we talked that today I could never fit into the life of my old profession. I was asked if the art directors I worked with directed all my sittings. I was aghast. In all the years I worked for *Harper's Bazaar* I was never told what to do with a photograph, and Alexey Brodovitch never came to my studio on a sitting. The only time he'd put in an appearance was for parties. Even the great art directors of three of the most important advertising agencies—Art Bloomquist, Arthur Weiser, and Lester Lowe—never interfered.

In the class magazines of today, there is a colossal change—commercialism is rampant. It is impossible to tell where the editorial pages begin as there is an endless procession of corny, glossy color advertising and editorial color too, all screaming in one voice to be heard. And in fashion photographs, women pose like men, with faces devoid of expression and mean eyes—the gun moll look!

Photographers should rise and fall by their own ability, but this should apply to art directors too. If they are going to interfere, they should take the trouble to learn the art of the camera—how to operate it, in all its phases—and take the pictures themselves!

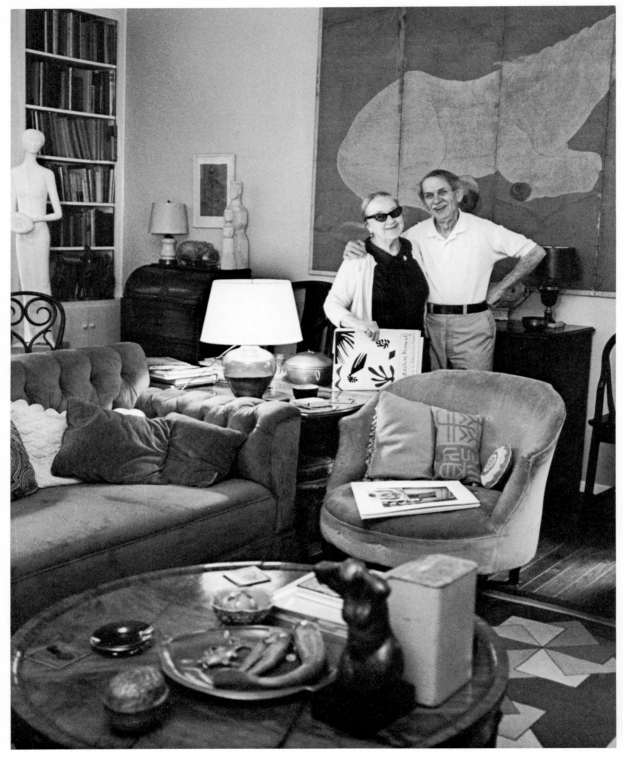

Mike and me at home in the country, 1977 (photo: Margaretta Mitchell)

# EPILOGUE

The *Bazaar* was heaven for twenty-two years. But in 1958 Carmel Snow and Alexey Brodovitch resigned. The new art director put in a surprise visit to my studio and had the presumption to look through my ground glass at what I was photographing. This had never happened in all my years. Suddenly my enthusiasm vanished. Enthusiasm for me was half the battle. The great era of my magazine was finished. This was no longer my cup of tea and I resigned. While I went to *Vogue* for most of a year and had a good time, on thinking back my memory is haunted still by a remark that Carmel Snow made to me sometime after the end of the war: "My dear, life will be very difficult in the future." I realize now that she was talking about the coming world of technology—the machine age, a commercial age. And so I retired to the country.